ESSAYS ON
NATIVE MODERNISM

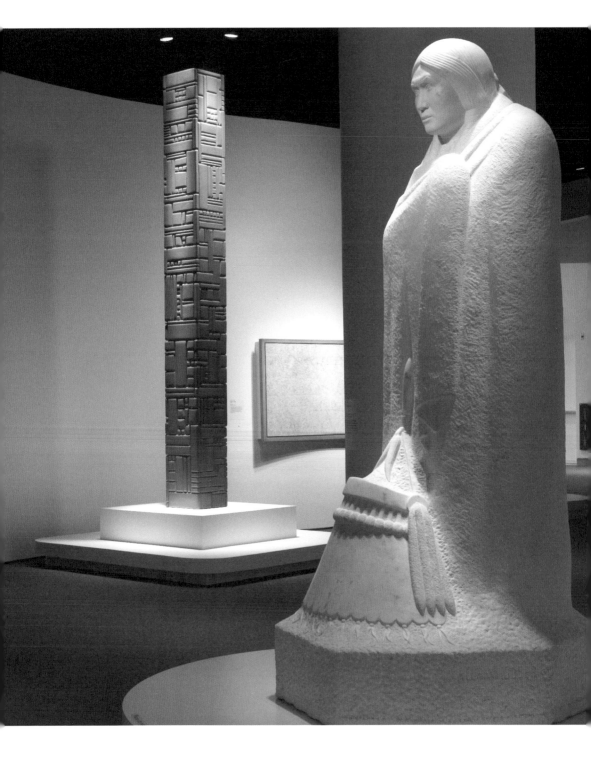

NMAI EDITIONS

ESSAYS ON NATIVE MODERNISM

Complexity and Contradiction in American Indian Art

National Museum of the American Indian
Smithsonian Institution
Washington, D.C., and New York

Library of Congress Cataloging-in-Publication Data

Essays on native modernism : complexity and contradiction in American Indian art.
 p. cm. — (NMAI editions)
Includes index.
ISBN-13: 978-1-933565-02-6 (alk. paper)
1. Indian art—United States—Congresses. 2. Art, American—20th century—Congresses. 3. Indian art—Canada—Congresses. 4. Art, Canadian—20th century—Congresses. 5. Modernism (Art)—Influence—Congresses. I. National Museum of the American Indian (U.S.) II. Series.
N6538.A4E87 2006
704'.0397073074753—dc22
2006015035

Manufactured in the United States of America
The paper used in this publication meets the minimum requirements of the American National Standard for Permanence of Paper for Printed Library Materials Z39.48-1984.

National Museum of the American Indian
Head of Publications: Terence Winch
Editor: Elizabeth Kennedy Gische
Designer: Steve Bell

The Smithsonian's National Museum of the American Indian works in collaboration with the Native peoples of the Western Hemisphere and Hawai'i to protect and foster indigenous cultures, reaffirm traditions and beliefs, encourage contemporary artistic expression, and provide a forum for Native voices. The museum's publishing program seeks to augment awareness of Native American beliefs and lifeways and to educate the public about the history and significance of Native cultures.

For information about the Smithsonian's National Museum of the American Indian, visit the NMAI website at www.AmericanIndian.si.edu. To support the museum by becoming a member, call 1-800-242-NMAI (6624) or click on "Support" on our website.

TITLE PAGE: *Comrade in Mourning* (1948) by Allan Houser and *Red Totem I* (1977) by George Morrison (foreground and background left) were focal pieces in the exhibition *Native Modernism: The Art of George Morrison and Allan Houser* at the National Museum of the American Indian in Washington, D.C. Photo by Ernest Amoroso.

Table of Contents

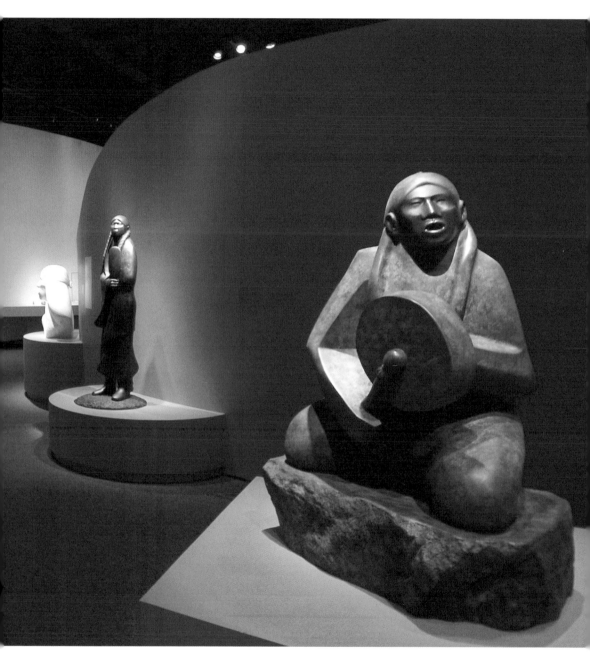

Apache (1986), *As Long as the Waters Flow* (1988), and *Songs of the Past* (1993) by Allan Houser (from left to right) were among the works presented in *Native Modernism: The Art of George Morrison and Allan Houser* at the National Museum of the American Indian in Washington, D.C. Photo by Ernest Amoroso.

W. RICHARD WEST, JR.

(Southern Cheyenne and member of the Cheyenne and Arapaho Tribes of Oklahoma)
Founding Director, National Museum of the American Indian

ARTISTIC VISION/NATIVE VALUES

AT THE NATIONAL MUSEUM OF THE AMERICAN INDIAN, we aspire to provide a place and means for the indigenous people of this hemisphere to tell their own histories in their own words and in their own ways, and to explain what their worldviews and arts mean to them and to the broader world. For millennia before the arrival of Europeans to these shores, and in the more than five hundred years since, Native people have made and continue to make extraordinary contributions to the fabric of our societies and our collective and individual consciousness. While not seeking to replace existing scholarship, the National Museum of the American Indian is here to create a place to include Native voices, which have so often been excluded.

It is in this spirit that we opened the museum on the National Mall in Washington, D.C., in the fall of 2004 with the groundbreaking exhibition *Native Modernism: The Art of George Morrison and Allan Houser* and published a striking book of the same name in conjunction with the show. We followed up in the spring of 2005 with a lively symposium at the Mall museum on the subject of Native modernism, which provided the basis for this volume. Our efforts are sorely needed. American art history has not heretofore taken account of the multitude of Native people producing art. When Native artists have been included, it has often been as a footnote or afterthought—and most certainly, not on their own terms. But, as George Morrison himself suggested, if you don't know Indian art, you are missing the majority

of American art history. Through exhibitions, symposia, and books such as this one, we intend to make it known that the canon of American art history must encompass the crucial contributions of Native people.

Through deft explanation and vigorous elaboration on its meanings and influences, the distinguished essayists in this book continue and expand the dialogue on Native Modernism—and reshape the canon of American art into to a richer and more inclusive form.

Allan Houser and George Morrison stood at the midpoint of the twentieth century and changed forever the creative lives of the legions of artists they taught or influenced. Today, it is difficult to fathom that both of these creative giants were told that their work was inappropriate, or not "Indian" enough. Or, in fact, they were told it was "Indian art" rather than "art," and therefore could and should only be considered within that limited category.

A prevailing aesthetic in the first half of the twentieth century held that Indian art was to be "authentic" and not to reveal non-Indian influences. In painting, the Studio Style—named after the art studio at the Santa Fe Indian School—purported to be a traditional, acceptable style yet was largely influenced by Anglo culture's romanticism about Native people. The style, as Dorothy Dunn, the first teacher in the Studio, wrote in *American Indian Painting of the Southwest and Plains Area*, "sought to continue basic painting forms, and to evolve new motifs, styles, and techniques in character with the old [read that as 'traditional'], and worthy of supplementing them." Using mainly tempera paints, students were directed to depict ceremonial or traditional culture of their tribes in a flat, decorative, linear style, primarily with an absence of background, perspective, and ground.

Allow me to digress for a moment and reflect upon the career of my father, Dick West, an artist trained in this school of traditional Indian art. When he bridled against that school, he encountered obstacle after obstacle in his desire to paint in more abstract and cubist styles. Certainly, he could paint as he wished, but he was roundly criticized for venturing beyond the confines of his Cheyenne culture. His abstract pieces, fortunately for me, were relegated to his personal collection.

This was the customary critical stance about Native American art at the

time Morrison and Houser began their careers. For George Morrison, who received classical training in the history and practice of art and was immersed in the discourses of mainstream modernism, painting in a shared or defined style was inapposite. Morrison valued originality. Allan Houser's training at the Santa Fe Indian School Studio, on the other hand, was within the realm of "Indian art," with its restrictions on imagery, style, and media. He was largely self-taught about the techniques and broad possibilities of non-Native art history and practice. His unique vision coalesced in sculpture.

Both artists felt pressure to return to their own traditions, their own Indian roots. Fortunately for us, Morrison and Houser understood that Native people were as much a part of modernity as anything swirling around them. The definition of tradition has forever been tied to the notion and word "unchanging," when the only true point to be made about a slippery concept like tradition is that it keeps changing to remain vital. Art can facilitate change as much as it can guard against it.

Both men exerted great influence through the expansive fortitude of their artistic vision and their capacity to teach and inspire. Houser's sculptures evoked modernism as much as they did Native values, and throughout his thoughtful life he demonstrated that these characteristics were not necessary antithetical. Through his art, Morrison sought to develop an individualized aesthetic and a path of his own.

This book celebrates these two men's extraordinary lives. Moreover, it explores the broader movement the men forged, through their personal styles, friendships, mentoring, and art production. We invite you to join in this important dialogue about Native modernism, its place in the canon of American art, and the currents of influence between them.

We extend our thanks to the distinguished participants in the National Museum of the American Indian's symposium on Native modernism, some of whom produced the illuminating essays found in the pages of this book. Thanks are also due to Truman Lowe (Ho-Chunk), Gerald McMaster (Plains Cree and member of the Siksika Nation), and Bruce Bernstein for their work in developing the symposium, and to Nicole Oxendine-Poersch (Lumbee) and Rebecca Trautmann for their diligent attention to the myr-

iad details involved in bringing such an event to fruition. This book could not have been produced without the commitment of the museum's office of publications, especially Terence Winch, head of publications, and Ann Kawasaki. Editor Elizabeth Kennedy Gische devoted her talents to bringing out the best in its authors. Thanks also to Steve Bell and Leslie London for their handsome book design.

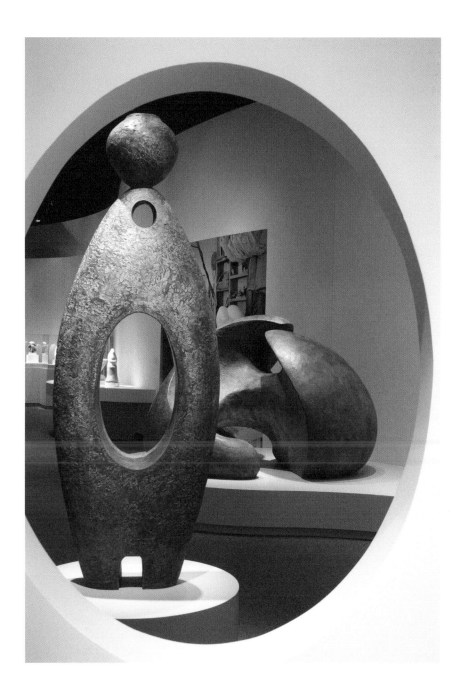

Watercarrier (1986), foreground, and *Next Generation II* (1989), background, both by Allan Houser, on display in *Native Modernism: The Art of George Morrison and Allan Houser* at the National Museum of the American Indian in Washington, D.C. Photo by Ernest Amoroso.

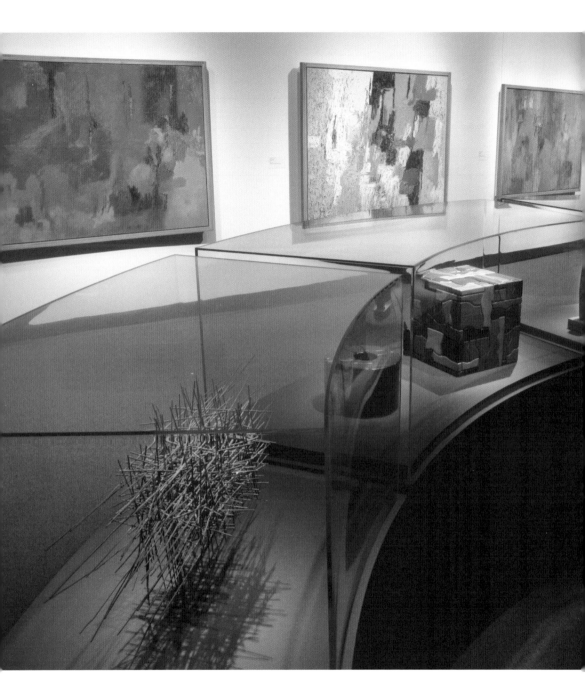

This installation view of *Native Modernism: The Art of George Morrison and Allan Houser* features paintings and sculpture by George Morrison. Photo by Ernest Amoroso.

BRUCE BERNSTEIN TRUMAN T. LOWE

New Horizons

Art is, in its most fundamental sense, an expression of the artist's own perspectives and understandings of the world. Authenticity is truth to self. Within this point of view, the National Museum of the American Indian (NMAI) opened in September 2004 with an exhibition about Native modernism and the enduring legacies of two twentieth-century giants, George Morrison and Allan Houser. We do need to ask ourselves the obvious question: can there be modern art in a museum about the indigenous people of the Americas? The answer is a resounding yes. But let us explain further.

First, we need to dismiss those critics who believe that authentic Indian lives ended long ago—those who expected headdresses and bows and arrows to be the icons of the new museum. While symbolic of Native lives, such objects are not the only artistic means of self-expression. Indian people enjoy automobiles, cell phones, Internet, travel, restaurants, and shopping for—rather than making—most of their own clothes. Ironically, while Indians and Indian arts and crafts represented a type of anti-modernism to the American public at large in the pre–World War II era, in fact Indian artists and craftspeople and their families sought through their earnings access to cars and other manufactured goods.

Indian people have survived, thrived, and flourished. We can also say that Indian people have, for the most part, survived with style and grace because their cultures and traditions are dynamic. In short, we should understand

change as a strength of Native culture. Why then should we—at the start of the twenty-first century—worry whether or not Native art is traditional?

Because Native art comes out of societies that some perceive as "less advanced" than European-based systems, Indian art is sometimes relegated to categories of craft. Viewed as craft, Indian-made art is interpreted as replication of existing forms rather than the celebration of creativity, change, and continuity it presents. Contemporary art made by Native people deserves to be considered on its own merits, and not against chimerical standards of imposed and sometimes imagined tradition and authenticity. Whether completely new or a continuation of established forms, Indian-produced art reflects the world in which the artist lives.

The Native Modernism Exhibition

The two men who were the subject of NMAI's trailblazing inaugural exhibition at its new museum in Washington, D.C., and a major focus of the symposium upon which this book is based, stood at the crossroads of such debates and perceptions. *Native Modernism: The Art of George Morrison and Allan Houser* featured almost 200 drawings, paintings, sculptures, and prints by George Morrison (Grand Portage Band of Chippewa, 1919–2000) and Allan Houser (Chiricahua Apache, 1914–1994), the vast majority of which were on loan from public and private collectors. Morrison and Houser are the most prominent artists of a formative generation in Native American art. Working from the mid 1930s to the late 1990s, each rebelled against ideas of what Native art must look like and instead evolved a personal and original style to achieve success as individual artists. Together they influenced subsequent generations of Native artists.

George Morrison's artistic path led him to abstract expressionism. As he traveled from his birthplace in Minnesota to New York and beyond, his evolving interest in Euro-American art resulted in a highly individualistic and colorful style of painting. Allan Houser is best known as a sculptor, and his sphere of success and influence was in the Southwest. Blending Native subject matter with a sleek modernist aesthetic, his elegant and highly refined art represents Native people in stone and metal with dignity and compassion.

Truman Lowe, professor of art at the University of Wisconsin–Madison, an internationally known sculptor and member of the Ho-Chunk from the Black River Falls Indian Mission in western Wisconsin, served as curator of the *Native Modernism* exhibit and conceived the symposium from which this book arose. The story behind the development of this landmark exhibit emerged as Bruce Bernstein, then assistant director for cultural resources at NMAI, sat down with Lowe to talk through the plans for the symposium and book. As Bruce's questions elicited Truman's reflections, a fascinating background to *Native Modernism* was revealed, which we share below (through p. 21).

Bernstein: Not insignificant to the exhibition or symposium, George Morrison and Allan Houser are part of your—and every other working Native artist's—personal journey.

Lowe: Yes, it was probably destiny for me to create an exhibit on Morrison and Houser, two individuals with whom I was very familiar and both of whom I'd met. Their examples were really key for a person like myself, who was in the middle of becoming an artist.

Morrison and Houser liberated the next—and subsequent—generations of Native artists. They showed that you could sustain yourself through your art. And, moreover, that teaching is a good and viable addition to an artist's life. Many of us still had to figure out a way to survive, so we ended up teaching—for example, George Longfish at the University of California-Davis, Edgar Heap of Birds at the University of Oklahoma, and I continue to be a part of the University of Wisconsin–Madison.

I can tell you from my own biography why figures such as Morrison and Houser were needed. When I was growing up in Wisconsin, there was never anything in high school courses that dealt with Native people; as if nonexistent, we were ignored. Ironically, the school was just a few miles away from the Black River Falls Indian Mission. Consider, too, for a moment that when Morrison and Houser were born, Indians were not United States citizens.

Bernstein: Does it matter that Morrison and Houser were Indian? While an artist never sheds his or her identity, do we as viewers appreciate the art because it is Indian, art, or both? Rick Hill, a Tuscarora colleague, spoke once of what he described as "genetic memory," by which he meant in essence that "Indians [regardless of the hardships] are not through being Indians yet, so we can't stop time, there can't be an ahistoric time ... because everything and anything is who we are."

Lowe: One of George's major goals as a teacher was to encourage young Natives. Allan, too, wanted to encourage Indian people, which is why his years teaching at the Institute of American Indian Arts [1962–75] were so successful. But for both men, it was not talking about or taking on the appearance of being Indian, but rather the way you lived your life.

The question of whether the art is really Native, or whether these men should be considered Native artists, has come up. I choose to think in terms of authenticity, by which I mean authenticity to themselves as individual artists. The bottom line is that it really doesn't matter. It's really more about being human. There's a kind of understanding that takes place in their work that transcends the notion of blood quantum (an idea that has been used in defining Indians, and that Native people sometimes use against each other, too). Allan and George were both inclusive, viewing themselves as standing in the middle of their own heritage while projecting that world and the outside world in order to fashion the most successful lives possible.

Bernstein: You are among the next generation after these two artists, an inheritor, if you will, of their legacy. I understand that you learned about Morrison via a graduate seminar.

Lowe: I became aware of George Morrison while I was taking an anthropology class at the University of Wisconsin called Indians of the Western Great Lakes Region. Life is filled with irony—of course I am an Indian from the Great Lakes region. Taught by Nancy Lurie, who became a lifelong friend and supporter, the course dealt not only specifically with Natives in Wiscon-

sin but also in particular with the Winnebago, which is what the Ho-Chunk were called back then.

I told Dr. Lurie that I wanted to write about contemporary artists from the area. And, of course, there weren't any back then that I knew of, so it took some hunting. Finally, one of my colleagues in the art department, who had spent quite a bit of time in New York City at the Cedar Bar (where all the artists hung out), said, "You know, there was this one Indian. Let me think about it." Then he came up with the name George Morrison.

I called Morrison, and went to visit with him in Saint Paul, where he was in the process of moving from New York. We became very good friends, and he would invite me to many of his openings. We would also drive up to his home in northern Minnesota and spend time there.

For me, the friendship served as a good introduction to what a professional artist's life is all about. And that's the part you don't get in grad school or in any other school. It's a difficult field. The challenge of being an artist certainly resonated with me personally, but more so, the admiration for what George had achieved. For a Native person, there were really not many role models around—a few guys here or there, but none working on contemporary, abstract art.

Even before calling him, I was impressed because he had exhibited with the abstract expressionists. The very first time I met him, I walked into his studio, which was a converted church, and thought, "God, look at this." It was the ideal of what I believed an artist and his surroundings should look like. More important, I remember imagining myself being a serious artist. Morrison lived it, he talked about it every day, he associated with other artists—his library was filled with art books. His life was that of a professional artist. At that point, he enjoyed a relatively successful career as an artist.

A few years later, after I had joined the art faculty at the University of Wisconsin–Madison, we asked George to come to Madison as a visiting artist and to give a lecture. He was heavily into collage work during this period. But he was running out of wood—you'd think there would be enough driftwood, or some kind of wood, in Minnesota, with its 10,000-plus lakes—but here he is, running out of materials. We took him over to the

federal government's Forest Products Lab where they were researching wood aging, and they showed him how to make weathered wood.

So, the next time I visited him, there he was, making aged wood. He had shelves of wood that he watered like plants. When the wood got gray enough, he would flip it over and do the other side. There was a real seriousness to all this that reminded me of what it takes to be a full-time artist. George was an excellent exemplar.

Bernstein: You were similarly awestruck when you met Allan Houser in the mid 1980s, feeling that he broke all the stereotypes.

Lowe: I only had the opportunity to meet Allan twice. He was impressive—intense, physically active. He was a role model both as an artist and a teacher. Allan was dedicated to bringing Native people into the art world, not to be Indians per se, but rather to be artists.

Moreover, one cannot underestimate his influence; walk around any Indian art fair anywhere in the United States and you can see the legacy he produced. People say that Houser looks like the Southwest; on the contrary, Houser's work made the Southwest visual and easily recognizable. Houser still does not receive the recognition he deserves for transforming the whole idea of tradition with contemporary materials and techniques.

I first learned about Allan Houser from my fine high school art teacher—she was probably the person in high school who most influenced me, and she really had me focus on art. She was very supportive, and I began to spend most of my free time in the art room. I asked her once if there are Native artists and, if so, how come we don't talk about them. She introduced me to whatever she could find on Houser, which at the time were his paintings. As a result, I became intrigued by the idea of becoming an artist. I later encountered his sculpture, and I have remained fascinated by his large-scale work.

Allan Houser had a modernist approach to both materials and work. He built himself a compound on property south of Santa Fe that included separate indoor and outdoor sculpture studios and a drawing studio, too, along with acres of space to display work. He was one of the first, if not the first,

Native artists to introduce sculpture and working not only in stone but also in other sculptural media. It was not an easy road, but his studio and grounds represented his success. Allan liked to choose his material and traveled to Italy for Carrara marble, selecting pieces that he felt indigenously held the forms inside the stone, ready for his hand to reveal them. Using a grease pencil, he outlined the form and did some of the rough-out work, then turned it over to his assistants. Each of the assistants was also one of his students, some having matriculated through the Institute of American Indian Arts.

Allan was "impatient." I put that in quotes because he had patience, but his mind was always working—by the time he finally got to the making of a piece, he was already working on subsequent pieces. He was a creative force.

Bernstein: Talk for a minute, from the perspective of the Native world, about the fact that Allan, who comes from a very traditional background, draws female forms as he did and from life.

Lowe: Houser's use of the female nude form was innovative for an Indian artist, but only because the larger art world had placed so many constrictions on artists who were Native. In New York, Morrison could sidestep some of these issues and do the type of work that called to him; however, he told me about a few moments when his peers suggested that he return to the reservation and make Indian art. Nudes were not particularly accepted in Native communities, but an artist needs to know, to understand the human form. Allan had a strong work ethic and desire to become a complete artist. In the end, the majority of his work represents the respect he holds for women, and metaphorically what he feels for the Southwest, the environment, and his own tradition.

Using the nude in the manner Allan did, while a real departure from conservative mores within Native communities, was just as much about the utilization of this time-honored form for the non-Native world by an artist. In this we find a core of Allan's genius: his ability to bring disparate but artistically necessary outlooks together.

The nudes are an example of the exhibition's aim to expand people's hori-

zons and understandings about who Native people are. Many people asked if the nudes belonged in an Indian museum. My point of view was that I was just trying to show Morrison and Houser as artists who were working during the same time period and involved in some of the same processes as well. It's no different than for any other practicing artists. Artist training includes figurative drawing, so I wanted to make the point that both men were highly trained and skilled artists, who took their work with seriousness. While George was formally trained in art school, Allan's emphasis on human form represents his desire to immerse himself in the art world and its practices. There is a wonderful irony in the museum building itself in that Santa Clara Pueblo artist Roxanne Swentzell, born in 1962, is able to create a monumental sculptural relief for NMAI's Washington, D.C., building that includes nudes—and there's not even a second thought in Roxanne's mind whether or not those nudes would be incorporated in her piece (see p. 21).

Bernstein: Both men deserve a lot of credit for breaking boundaries within the Native community through their work.

Lowe: George painted the way he wished; there was nothing sentimentalist about his approach or subject matter. He was able to break boundaries through perseverance. Allan introduced sculpture and carving, working in stone, bronze, and steel. There was no Native contemporary sculpture until Allan taught it at the Institute of American Indian Arts, instructing his students to follow their hearts because here they knew who they were, while also teaching them about materials and techniques. Both men are larger than life because their contributions transcend the work they produced as artists. Their work embodies the breaking of imposed sentimentalist shackles. Both men broke those inflicted limitations and ultimately achieved success. Certainly they found economic success, but the more important success was the influence and impact Morrison and Houser continue to exemplify. In my time, these were people we called giants.

Bernstein: Native Modernism was presented to an audience heretofore largely unaware of Morrison and Houser's legacy. The exhibit was important as a means to have the work of these artists seen by millions of people and to stimulate critical discussion of their art and the contributions they made in their lifetimes and beyond.

Lowe: Allan passed away in 1994, so discussions proceeded with his wife, Anna Marie Houser, and two of his sons, Phillip Haozous and Bob Haozous. The family was definitely interested in NMAI's hosting an exhibition, but they wanted to be sure that Allan would be discussed as an artist, that the breadth of his career and work would be exhibited. Allan's first monumental stone piece, *Comrade in Mourning*, had never left Haskell Institute (now Haskell Indian Nations University) in Lawrence, Kansas, where Allan had carved it in a poorly ventilated basement in 1948. Allan told me that after he had placed his family with his parents in Oklahoma, he began work with

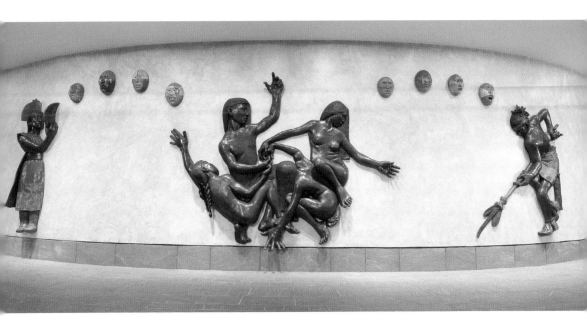

Roxanne Swentzell (b. 1962), *For Life in All Directions*, 2004. Collection of the National Museum of the American Indian (26/4546). Swentzell's monumental cast bronze sculptural relief and ceramic masks are prominently placed on the outside wall of the Rasmuson Theater at the NMAI, Washington, D.C. Photo by Walter Larrimore.

nothing more than a hammer and chisel. He had never worked with marble or on such a large scale. We strove to include this excitement of experimentation in the exhibition.

I visited Morrison, who was ill and increasingly frail, in 2000 at his home and studio on the Grand Portage Reservation in northern Minnesota to discuss the proposed exhibition. He wanted to know how serious we were about it—George didn't want just a small exhibit. I told him that I envisioned it as a comprehensive exhibit—that we were going to find as much as we could of his work to include. George died about six weeks later.

The work is never done; although George's and Allan's lives have passed, they are alive in their work and in their students and all the artists they inspired. They helped launch us into the mainstream on the great current of Native modernism that is continually changing. "Native modernism" is diverse and resists definition, yet four words are key to me. One is "origin," and by this I mean roots, knowledge of one's past. The second is "vision," a newness of interpretation open to the contemporary, the here and now. "Place," which reflects where we came from, is also important. It's about the land and the local, whether it be urban, suburban, rural, or reservation. And last, and full of emotional meaning to me, is "voice." All four are vital parts of images that speak in a visual language to all of us, as the works of Morrison and Houser have. Their messages are profound; they tell us who we were and who we will become.

The Native Modernism Symposium

In the year that it was on view, *Native Modernism: The Art of George Morrison and Allan Houser* was seen by millions of visitors. Well received by critics and public alike, the exhibition represented a full spectrum of each man's artistic legacy. Over long and productive careers, Morrison and Houser challenged and helped redefine prevailing conceptions of Native American art. In presenting the work of these two pioneering twentieth-century artists, we hoped that visitors would understand how they laid the foundation for

contemporary Native American art not only through their own artwork but also as teachers and mentors to succeeding generations.

We decided to build upon this foundation with a symposium that would continue a dialogue about the men's legacies as well as explore the basis of a "Native modernism" by eliciting a broad discussion about the critical perspectives and practices of Native artists across North America. While George Morrison and Allan Houser are seminal figures of this modernist era of Native American art, the symposium addressed the larger conditions within which their art was created. We also examined Native modernism in the context of the American art canon and traced the currents of influence between them.

The gathering, held on May 6 and 7, 2005, at the NMAI building in Washington, D.C., brought together a diverse group. Personal stories about Morrison and Houser were punctuated with academic presentations. Tribal people, fellow artists, and family members were there to reflect upon Morrison's and Houser's lives, work, and legacies. Art historians, art critics, and art curators attended, and some delivered scholarly papers.

Rick Hill, Sr., a member of the Beaver Clan of the Tuscarora Nation, moderated the symposium, adding his own insights to the proceedings. Since 1973 he has served as a visual artist, writer, museum consultant, curator, educator, and lecturer. He is currently a guest lecturer at the Six Nations Polytechnic in Ohsweken, Ontario, and the Tekarihwake Program in the Language Studies Department at Mohawk College in Hamilton, Ontario. From 1992 to 1995, Hill was Assistant Director for Public Programs and Special Assistant to the Director at the NMAI.

Hill opened the symposium with the following contextual notes: "George Morrison and Allen Houser were two of the people who influenced my own people about art—about Native artists and about the art world in general. We have gathered here today to honor that influence. Many people—not only this current generation of Native artists—played a role in creating a stage for future art. It's a bit of a difficult journey." He added an observation from personal experience: "When I went to art school in Chicago in 1968, the last chapter of our art text covered Native art. Of course, in art school, you never get to the last chapter. There is so much up front. The em-

phasis is always on European and Euro-American art. Native art was part of the mix, but it really did not get its due respect."

Art is a spiritual and subjective experience, Hill asserted: "Artists in Native communities draw inspiration from many different sources. There is no pure Native aesthetic. While we think we know all of the influences on us, we can also sometimes find other ancestors and connections. If we all went walking through the art gallery, we're not all going to respond the same. Somehow, certain artwork captures your imagination and your soul, and then you carry that with you for the rest of your life."

Hill observed that disagreements are helpful because "we need to contest each other's ideas, and we need to put some pressure on each other to seek a deeper understanding of the function of art in Native society." Artist, curator, and writer Jolene Rickard (Tuscarora), currently an associate professor at the State University of New York–Buffalo in the Department of Art and Art History, spurred discussion toward greater complexity by posing a number of challenging questions, such as: "What are the implications of locating Native art within the categorization of modern? If 'modernism' is a theoretical formation of the philosophical West, where does art beyond the 'West' fit? Is Native art beyond the 'West'? As provocative as the rejection of framing Native art as modern can be, is it also strategic to be 'modern'?"

Reflections by Family and Friends

As part of the examination of the legacy of Morrison and Houser, we invited family and friends to the symposium to share their remembrances of the two men. Hazel Belvo, wife and artistic comrade of George Morrison for many years, reminisced about their life together. She spoke about his work in surrealism and abstract expressionism, his years in New York City, and his friendships with artists, both Native and non-Native. Belvo recalled discussions among the abstract expressionists about inner light and the freedom to manifest that inner vision. "I think that was where George could identify in an authentic way with abstract expressionism. And his mark was the outer manifestation of that." She provided a vivid vignette of Morrison's painterly technique:

When I think about his symbolic and literal mark, I think about his paint brushes. I wash my paintbrushes really carefully—I probably have the first paintbrush I ever owned. But George let his paint brushes get stiff, so that they were more like sticks. And he loved to paint with those stiff paintbrushes. I think that he could feel the mark more somehow.

In closing, she quoted a few words that George wrote about himself after he left New York to return to Minnesota and his studio on the shore of Lake Superior: "I have come back to the magic of the lake, the power of rocks, the enigma of the sky, that which is in both my life and my heart."

George and Hazel's son Briand Mesaba Morrison (whose godfather was the abstract expressionist painter Franz Kline) also shared memories of his father, speaking of his strength throughout his illnesses, and noting that although George Morrison was bold, he was also sensitive, with a kind of quietness and gentleness about him.

Kent Smith (Chippewa), professor of American Indian Studies at Bemidji State University in Minnesota, remembered Morrison not so much for specific conversations, but rather for his company. Smith recalled, "I learned a lot from him—two lessons in particular. The first is belief in working every day. He taught me this not by talking but by overcoming the numerous physical hardships of his life. The second is to remember where I am from. It's somewhat easy being Indian because you have a sense of place. When somebody asks you, 'Where are you from?' and you tell them—they know what you're about."

The Houser Inheritance

David Rettig, who has known the Houser family for about thirty years, represented the family at the symposium. Rettig met Allan Houser during a first visit to Santa Fe in 1976; he later became a gallery owner representing the work of Houser's son Bob Haozous and others. For the past ten years, he has worked with the Allan Houser Foundation. Speaking of Houser as one of the great modernist artists of the twentieth century, Rettig recalled

Houser's determination and generosity, and the dignity inherent in his personality. From childhood, Rettig said, Houser was drawn to art: "He started drawing as a kid. There weren't any art schools in the Fort Sill area, nor were there any artists—there wasn't anyone encouraging Allan to pursue art, but he was warm with the muse. He was born with talent and desire."

Artists Clifford Fragua (Jemez Pueblo) and Tony Lee (Navajo) also discussed Houser's legacy. Fragua, a sculptor who works primarily in stone, was one of Allan's students at the Institute of American Indian Arts. He recalls: "Houser had such courage, and he taught his students about integrity, to be true to yourself. This is what he instilled in me, and what I try and pass on to my children, my students, and anybody I come across. His work sparked a movement, a sculpture movement that has spread widely."

Tony Lee worked in Allan Houser's sculpture studio from 1989 to 1994. Houser advised Lee to be unique rather than try to be like everyone else in the sculpture business: "Working with him was an honor. I remember that he always said, 'Whatever you like to do, follow that direction.'"

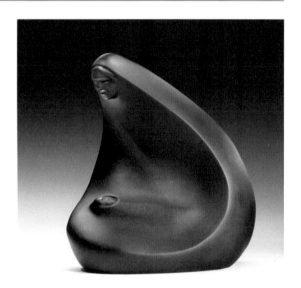

Allan Houser, *Reverie*, 1981. Bronze, 63.5 x 58.4 x 33 cm. Collection of the National Museum of the American Indian (25/7238). Photo by Ernest Amoroso.

Scholarly Essays

The essays in this book derive from the scholarly papers delivered at the symposium. In "Other Native Modernists: What's in a Name," J. J. Brody, professor emeritus of art and art history at the University of New Mexico, asserts that several artists from San Ildefonso Pueblo in northern New Mexico who began to sell their paintings to art collectors in 1917 were among the earliest Native modernists in the United States. Among these artists were Crescencio Martinez (1879–1918), his nephew, Awa Tsireh (Alfonso Roybal, 1898–1955), and Oqwa Pi (Abel Sanchez, 1899–1971). Brody examines certain of their paintings to show how they fit as Native-made modernist art objects within the early twentieth-century modernist tradition of northern New Mexico.

Gerald McMaster (Plains Cree and member of the Siksika Nation), curator of Canadian art at the Art Gallery of Ontario, contributes "Post-Reservation Perspectives," in which he elucidates the indigenous contemporary artistic practice of Canada—and to some extent the United States—by examining the conditions of the early twentieth century out of which it evolved. Native artists have played a significant role in articulating a contemporary identity, he points out, with incisive works and methods that address a new attitude in a complex and contradictory world.

"Modern Spirits: The Legacy of Allan Houser and George Morrison" by W. Jackson Rushing III of the University of Texas at Dallas describes how, against long odds, Houser and Morrison invented themselves as artists. By imbibing the spirit of modern art, they enabled themselves to work in international styles, even as they celebrated and extended indigenous values. Despite the overt differences in their styles and the geographical implications of their work, Rushing identifies certain points of intersection in their careers and oeuvres. Ultimately, though, he concludes that their legacy is the model that their self-invention and quiet but tenacious determination offer younger artists. Implicit in this model, however, is the obligation that befalls society at large to establish opportunities and contexts in which emerging Native American artists can thrive.

In "Native American Art History: Questions of the Canon," Joyce M.

Szabo of the University of New Mexico argues that while the study of Native American cultural production has a long history in the field of anthropology, its presence as a part of the discipline of art history is much more limited, in time and depth. To the present day, very few colleges and universities offer courses in the history of Native American art, let alone advanced degrees in that specialty. From an initial examination of the lack of attention paid to Native American art by art historians, Szabo turns her focus to questions of the canon, or canons, of art history and how they are formed. Is Native American art becoming part of that canon? If so, how is that canon being developed? Is there a specific canon for Native American art itself? By questioning the ways in which stereotypes, marketing, named artists, and connoisseurship play roles in the formation of artistic canons, Szabo observes, we can also explore how modern art becomes part of the canon. As Griselda Pollock asked in 1999 concerning the writing of women into art history, How can we difference the canon to include Native American art?

In "The Raven, the Eagle, the Sparrows, and Thomas Crow: Making Native Modernism on the Northwest Coast," Charlotte Townsend-Gault of the University of British Columbia examines works by such artists as Robert Davidson, Bill Reid, and Debra Sparrow. Always in troubled relation to the past, always questioning the present, always desiring and querying the autonomous status of the work of art, always anxiously self-critical—these, she writes, were among the defining characteristics of modernism through a large part of the twentieth century. A prevailing notion of the cultures of "the Northwest Coast"—that is, Canada's southwest coast—as havens of tradition that somehow bypassed modern and moved directly into less-strict postmodern, overlooks the defining significance of these characteristics for Native art in British Columbia.

Settler colonization has much to answer for, Townsend-Gault notes, but, in North America particularly, its consequences are inseparable from the modernizing project. The disruptive forces of industrialization and urbanization provoked, and now help maintain—with what is understood as globalized capitalism—modern art's turbulent and paradoxical critique of the very conditions that have enabled its experiments. In urban British Columbia, it has allowed a degree of artistic freedom that often runs counter to

the constraints implicit in identifying with the protocols and traditions of a specific First Nations culture. These constraints themselves may be a protective response to modernity as well as to colonialism.

Conclusion

We trust that this book will contribute to the burgeoning conversation about the complexities and contradictions that mark the extraordinary endeavor of Native American art in the era of modernism and beyond. Freed forever from limited and confining interpretations, the exciting and challenging works of pioneers such as George Morrison and Allan Houser, and the innovative creations of subsequent generations of Native artists, should be studied, understood, and appreciated on their own remarkable merits and in the broad context of American art history.

George Morrison, *Untitled (Horizon)*, 1987. Lithograph (23/30), 66 x 182.9 cm. Collection of the National Museum of the American Indian (25/9064). Photo by Ernest Amoroso.

Crescencio Martinez (1879–1918), San Ildefonso Pueblo, *Buffalo Dance*, 1918. Gouache on paper,
37.5 x 58.4 cm. School of American Research, IAF. P19.

J. J. BRODY

Other Native Modernists: What's in a Name

In 1851, John Ruskin, among the most prolix art critics of the English-speaking world, wrote *Modern Painters*, a book in which he characterizes the paintings of J. M. W. Turner as the epitome of modernism. Turner was a magnificent and innovative artist but is rarely mentioned today in connection with modernism, and I cite him here only to illustrate the truism that "modernism" is a generationally defined concept with ever-shifting guidelines. My understandings of the term have not changed much since I was about age twenty, and I suspect that holds true for most interested people who were introduced to it when they were young. I first learned about modernism in the late 1940s and still conceive of it as an early twentieth-century visual and philosophical tradition largely derived from the union of Paul Cézanne's coolly intellectual rationality with Vincent van Gogh's idiosyncratic emotionalism. Almost two decades later, during the 1960s, I tweaked my notion of modernism by adding to the mix the aestheticism of the arts and crafts movement and the social attitudes of fin-de-siècle bohemianism.

Those views of modernism were shaped by the museums of New York City, a three-year-long certification program in fine arts at the Cooper Union, and less formal art classes at the Brooklyn Museum and the Art Students League. I studied with several modernist artists, tried very hard to be one, and in retrospect was most memorably instructed by museum exhibitions,

fellow students, and two avant-garde teachers: Will Barnet and John Ferren. I don't remember either Barnet or Ferren ever saying much about his own work, or even using the term "modernism," but I vividly recall each of them concentrating on the craft of art-making and the abstract qualities of pictorial space, and being quite specific in their rejection of the illusionistic conventions and deep pictorial spaces that had characterized Western European painting for the previous six centuries.

Rather than any kind of artistic mannerism or style, I learned in those years that modernism was a historical attitude supporting an ahistorical belief in the indivisibility of form and content, the union of subject and object, and, for two-dimensional objects, the tyranny of the picture plane. I also learned that—despite insistent propaganda by the contemporaneous art market and art-critical establishment—the high value given to creative individuality was not that important, for it was categorically necessary for all modernist art objects to share a family resemblance that transcended individuality, pictorial labels, styles, and artistic intentions. Each was its own subject and an intellectual exercise about itself. Each was made more or less meaningful and effective in proportion to its structural, technical, and intellectual integrity. True to the arts and crafts movement, modernist works were exercises in the ethics of art-making and, for that reason, their occasional use of bits and pieces torn from alien traditions was always potentially discordant and ethically questionable. I've never trusted the art of Paul Gauguin.

Finally, on the socio-historical level, modernism was an urban-based phenomenon that can only have emerged from a stratified society that conceived of art objects as individualized, highly specialized products made by entrepreneurs for sale within a capitalist marketing system to consumers unknown to the artists and belonging to other segments of that society. As commodities isolated from daily life, the most practical utility of these art products was as capital investments whose value was determined by market forces and marketing mechanisms. An elaborate critical system that isolated art products, their producers, and their intellectual and ethical grounding from those who acquired and used them is the most important of those mechanisms.

By my criteria, few modernists remain among us, for the last of them are mostly of my generation, children of the late 1920s and early 1930s who matured as artists fifty years ago. When I accepted the task of naming those I believed to be the first Native modernists, I knew that such people were either of my generation or an earlier one and that the likeliest candidates were to be found among the early twentieth-century Pueblo Indian painters who invented a regional tradition in and near Santa Fe in the Rio Grande Valley of northern New Mexico. There may have been other Native artists elsewhere who participated in modernism earlier, but those are the first I know of whose art was visually and philosophically compatible with modernism and who conceived of their work as their urban, modernist clients did—as an entrepreneurial market commodity.

The Earliest Native Modernists?

During the second decade of the twentieth century, two groups of Pueblo Indian artists in northern New Mexico began painting pictures that were compatible with modernism. They continued to work as artists for several decades thereafter for an enthusiastic and influential audience of recently arrived Euro-American ("Anglo") urban intellectuals. These included anthropologists, historians, and, most important, modernist poets, painters, essayists, novelists, and art patrons.[1] One group of Pueblo artists was from the small agricultural village of San Ildefonso and included Crescencio Martinez (1879–1918), possibly the first adult Pueblo artist to have painted for the Anglo market, his nephew, Awa Tsireh (Alfonso Roybal, 1898–1955), and Oqwa Pi (Abel Sanchez, 1899–1971). The other group, from several different pueblos, began painting as students at the Santa Fe Indian School in 1918 and included Hopi artists Fred Kabotie (ca. 1900–1986) and Otis Polelonema (1902–1981), and Velino Shije Herrera (Ma-Pe-Wi, 1902–1973) from Zia Pueblo.

San Ildefonso is a Tewa-speaking village about forty miles north of Santa Fe that had been accessible from there by rail since 1886. An art colony and archaeological center began to develop in northern New Mexico in about 1900, reciprocally supported by and supporting a growing ethno-tourism

Oqwa Pi (Abel Sanchez, 1899–1971), San Ildefonso Pueblo, *Hopi Snake Dance*, ca. 1925. Gouache on paper, 66 x 84 cm. School of American Research, SAR.1978-1-78.

industry that focused upon rural Pueblo and Hispanic villagers of the region. By 1917, when World War I had effectively closed off American access to the art centers of Europe, the transformation was complete, and the Pueblo Indian world had become an important attraction for peregrine artists and other intellectuals. Included among them were many modernists and latter-day advocates of arts and crafts ideals who came to the area on the wings of romantic and idealistic belief in the mystical values of "primitivism" that permeated those art traditions. Both the art and archaeological communities generally believed that the Pueblo Indian people were a remnant population characteristic of a preindustrial, ideal human social condition. Perceived of as a kind of living fossil, Pueblo society was to be envied and protected from change.

Significant contacts between the newly arrived intellectual community

and the pueblos that led to the creation of a new Pueblo art tradition began in 1907 when Santa Fe-based archaeologists started excavating ancestral Tewa villages. They hired Tewa Pueblo people, including many from San Ildefonso, as field workers, thereby creating many opportunities for cross-cultural teaching and learning experiences. Crescencio Martinez became a skilled field archaeologist and respected crew chief, and most of his surviving paintings were commissioned from him by archaeologists for whom he did fieldwork. Simultaneously, Pueblo ceremonial events that were open to outsiders, especially those occurring on calendrically scheduled feast days, became important attractions to the newcomers. For example, at San Ildefonso Pueblo a ritual Buffalo Dance was ordinarily performed every January 23 to publicly celebrate the Pueblo Saint's Day established by the Catholic Church calendar. Such public rituals were attended regularly by the intellectuals who discussed and wrote about them as spiritual, artistic events. They publicized them to friends, colleagues, and the international intellectual community by word of mouth and mail, and through magazine and journal articles. The dance was often described in mystical terms as a kind of modernist performance, evocative of several different spiritually and psychically oriented subsets of modernism.[2]

Paintings by Pueblo artists of those public ritual events became another mutually important opportunity for the two societies to learn about each other. The first such pictures seem to have been made by children at the San Ildefonso and Santa Clara Pueblo day schools before about 1910. Martinez, who was about thirty-eight in 1917 when he seems to have made his first gouache paintings, appears to have been the first Pueblo adult with some knowledge of the Euro-American intellectual world and its values who became an artist. Most of his forty or so documented paintings that are known today were originally acquired by participants in the modernist intellectual communities of Taos and Santa Fe.[3] All are of northern Rio Grande Pueblo men and women shown dancing in fully detailed regalia at one or another public ritual event.

Martinez's *Buffalo Dance* (see p. 30) is typical. The four leading actors of the performance are viewed as though seen from a rooftop as they enter the

dance plaza. Each is carefully detailed in costume and painted with anatomical realism, each brushstroke carefully building up an illusion of real-world action and three-dimensional musculature. Pictorial illusions of real-world spatial depth are implied by draftsmanship and the careful rendering of each figure, but the space within which they all operate is shallow and amorphous, its dimensions defined only by the carefully drawn walking figures who anchor themselves by gesture within a spatial void. Visually, the painting is a carefully balanced, self-contradictory fusion of two entirely opposed ways of rendering pictorial space on a two-dimensional surface. In that respect, it represents the essence of the emerging tradition, for it is on the surface a modernist fusion of traditional Pueblo pictorial principles and Western European post-Renaissance illustrative illusionism, and at a deeper level, a commentary about the juxtaposition of two opposing worldviews.

Painting and other forms of picture-making had been ubiquitous in the Pueblo world during the last two millennia, and for the last thousand years Pueblo artists—both men and women—made pictures on many different kinds of surfaces, including murals painted on interior and exterior walls of secular and ritual buildings.[4] Pueblo pictorial traditions in all media provide an unbroken link to the Pueblo past and history. Martinez and his younger contemporaries were not only familiar with those traditions but also actively participated in them as pottery and mural artists. Many of the formal qualities of traditional Pueblo painting that converged with modernist pictorial ideals while also being antithetical to Western European illusionistic art were incorporated by Martinez and the other Pueblo painters of that time into the new tradition that they were inventing for their Euro-American clients.

In both ancient Pueblo and modernist Euro-American painting traditions, action always occurred within uncertain but shallow pictorial spaces that provided a kind of micro-universe that framed off and isolated the actors in the picture from the "real" world. Life within those spaces followed an unknown and alien logic of different temporal and spatial conditions. As in cubist and surrealist paintings, the inhabitants of Pueblo murals often seem to hover in a nonspecific, timeless space within which

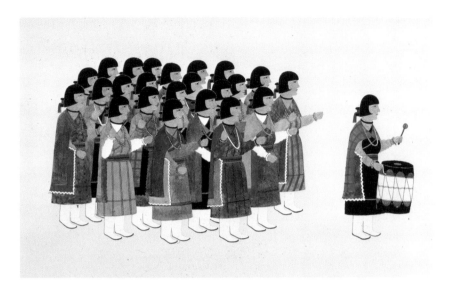

Awa Tsireh (Alfonso Roybal, 1898–1955), San Ildefonso Pueblo, *Woman's Chorus, Wheel Dance*, ca. 1922–23. Colored ink on paper, 29.2 x 50.6 cm. School of American Research, SAR.1978-1-288.

fish, birds, and unnameable organisms could each breathe in comfort, co-exist, and interact. It did not seem to matter whether pictorial shapes, forms, and colors were entirely nonobjective or illustrated real-world organisms, activities, or environments; these paintings certainly had iconographic and expressive intentions.

Awa Tsireh may have begun painting before Crescencio Martinez did, and his early paintings are very much like those of his uncle. As he matured after Martinez's death in 1918, he developed some distinctive variations on the basic spatial program that characterized the emerging Pueblo modernist tradition during Martinez's brief career. The pictorial space of Awa Tsireh's paintings became ever more shallow as he slowly abandoned the use of vanishing-point perspective and opaque, three-dimensional illustrative modeling. His marvelously decorative, abstractly rhythmic, and expressive paintings relied increasingly on the spatial conventions of traditional Pueblo prototypes even as their decorative patterning came to suggest Near Eastern and Far Eastern prototypes. During the early 1920s,

Awa Tsireh worked closely with Fred Kabotie and the other Santa Fe Indian School graduates and, as they all matured, they learned from one another and from interactions with Santa Fe's art community. The work of each one became increasingly individualized.

Kabotie, for example, was fascinated by the illusionism of magazine and book illustrations of that era. He learned to master the conventions of vanishing-point perspective, anatomical drawing, and three-dimensional modeling with color. Still, more often than not—and perhaps in response to his clients' belief that a background void might be "more Indian"—Kabotie placed his carefully rendered crowds of dancers within a background void. Through his skillful use of perspective, however, that void inevitably provided illusions of a real-world dimensionality that was tangible and measurable. Although he lived in Santa Fe until the 1930s, his mannerisms preceded him to Hopi, and his influence on Hopi Pueblo painting was profound and permanent. The contrast with the modern Rio Grande tradition may best be seen by comparing Kabotie's painting *Pine Dance* with a similar composition by Awa Tsireh titled *Green Corn Ceremony at Santo Domingo* (see pp. 39 and 40).

The pictures are packed with dancing figures and make effective use of background voids. But in contrast to Kabotie, whose use of perspective created a penetratingly deep pictorial space, Awa Tsireh avoided using Western European illusionistic conventions and instead pulled all of the action to the very front of the picture plane. Their works became textbook examples of modernist pictorial space.

Virtually all of Martinez's known paintings seem intended to be didactic, made to instruct novices about subtly different details of superficially similar costumes and dance movements. Many of his paintings were commissioned for precisely that purpose or collected as documentary souvenirs.[5] Similar motivations inspired the paintings done at the Santa Fe Indian School in 1918 by Kabotie and his young colleagues, all of whom were initially recruited to paint pictures of dances as souvenirs of memorable experiences. Again, in the early 1920s, several of the artists were asked by the Museum of New Mexico to make documentary paintings of Pueblo life, including

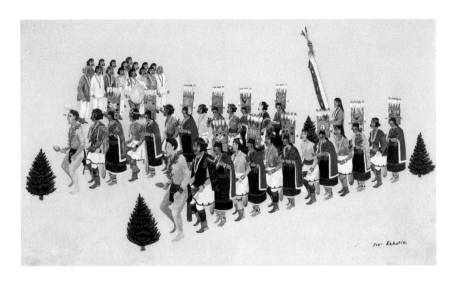

Fred Kabotie (ca. 1900–1986), Hopi (Shungopovi village), *Pine Dance*, ca. 1920–21. Gouache on paper, 36 x 54.8 cm. Museum of Indian Art and Culture/Laboratory of Anthropology, Department of Cultural Affairs, www.maiclab.org, 35488/13. Photo by Blair Clark.

ritual dances. After about 1922, when the Museum of New Mexico began to lose interest in purchasing documentary paintings, the ethnographic content gradually declined, to be replaced by paintings that were more appealing to the modernist tastes of the Santa Fe art community.[6]

Increasingly, throughout the 1920s and early 1930s, the modernist community of northern New Mexico recognized and characterized these Pueblo artists and their colleagues as an extraordinarily creative group of painters whose works were not only compatible with modernism but could be classified as modernist. Modernist painter Marsden Hartley and modernist art critic Walter Pach had written of early twentieth-century Pueblo people and painters as modernists, and their views were echoed, modified, and reiterated by other modernist painters, poets, and writers, including John Sloan, Alice Corbin Henderson, Mabel Dodge Lujan, Mary Austin, and Harriet Monroe.[7] All collected and promoted the Pueblo painters, all recognized and enthused about them, and all—especially the painter John Sloan—were involved in creating national and international exhibition opportunities for

those artists whose work they claimed had visual and philosophical parallels with modernism.

Perhaps their classification was correct, but even if so, that Pueblo modernism was a by-product of deliberate efforts by the artists to create, collectively and separately, pictorial methods to make their pictures more accessible to an alien audience. By using elements of Euro-American pictorial traditions with which they were familiar, while also relying upon traditional Pueblo formal methods, each of these artists developed a similar but uniquely personal method for harmonizing the visual conventions of the Pueblo world with some of those of the Euro-American invaders. The resultant tradition was a kind of illustrative pictorial formalism compatible with both contemporaneous modernism and traditional Pueblo painting.

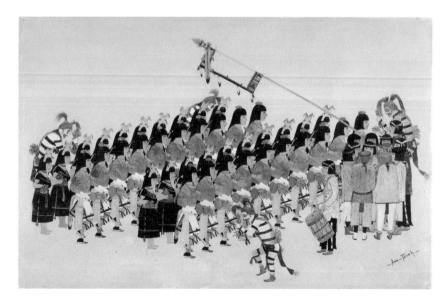

Awa Tsireh (Alfonso Roybal, 1898–1955), San Ildefonso Pueblo, *Green Corn Ceremony at Santo Domingo*, ca. 1922. Colored ink on paper, 45 x 68.7 cm. Museum of Indian Art and Culture/Laboratory of Anthropology, Department of Cultural Affairs, www.maiclab.org, 24018/13. Photo by Blair Clark.

NOTES

1. J. J. Brody, *Pueblo Indian Painting: Tradition and Modernism in New Mexico, 1900–1930* (Santa Fe: School of American Research Press, 1997).

2. See ibid., 92–94; Marsden Hartley, "Aesthetic Sincerity," *El Palacio* 5, no. 20 (1918): 332–33; "Tribal Aesthetics," *The Dial* 65, no. 776 (1918): 399–401; and "Red Man Ceremonials," *Art and Archaeology* 9, no. 1 (1920): 7–14; Edgar L. Hewett, "The Indian Ceremonies," *Art and Archaeology* 18, no. 5, 6 (1924): 207–14; Mabel Dodge Luhan, *Movers and Shakers* (New York: Harcourt and Brace, 1936), among many others.

3. Brody, *Pueblo Indian Painting*, 200, 210–11.

4. J. J. Brody, *Anasazi and Pueblo Painting* (Albuquerque: University of New Mexico Press, 1991).

5. Brody, *Pueblo Indian Painting*, 82.

6. Ibid., 151–60.

7. See, for example, Hartley, "Aesthetic Sincerity," 332–33; "Tribal Aesthetics," 399–401; and "Red Man Ceremonials," 7–14. See also Walter S. Pach, "The Art of the American Indian," *The Dial* 68, no. 1 (1920): 57–65.

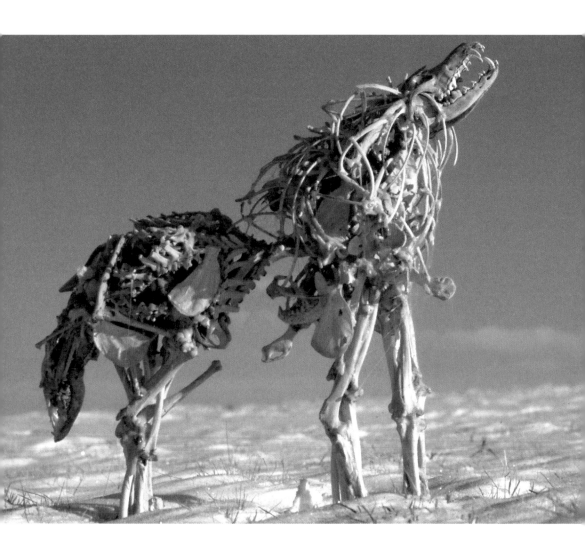

Edward Poitras (b. 1953), *Coyote*, 1986. Coyote bones and glue, 45.7 x 71.1 x 78.7 cm. Collection of Neil Devitt, Regina, Saskatchewan, Canada. Photo by Don Hall.

GERALD McMASTER

Post-Reservation Perspectives

In the 1970s, when I was a student at the Institute of American Indian Arts in Santa Fe, I took sculpting classes from Allan Houser. I walked into class one day and saw Allan sitting on his stool in his usual position. He was staring at his sculpture, looking a bit dejected. When I inquired about what was troubling him, he replied that he had hit the stone in the wrong way, and it had cracked along a rather chalky area, cutting the face he was working on almost in half. I liked the effect, and told him that it reminded me of an ancient artifact that had just been unearthed. He looked at me and didn't say anything. Then he said, "Okay, you can go to work now."

Several years later, after I was out of school, I saw a special issue of *Arizona Highways* magazine that featured on the cover—along with other works by well-known artists of the Southwest—the piece about which Allan Houser had been disconsolate. In a small fashion, this made me feel good that I had perhaps put a new way of looking at something in his mind. I couldn't help but be thankful for the chance to be with the master and share thoughts about his work.

This essay explores the opening of new perspectives. My purpose here is to elucidate the indigenous contemporary artistic practice of Canada—and to

some extent the United States—by examining the conditions of the early twentieth century out of which evolved today's (en)counter narratives.

Since World War II, the resurgence in both Canada and the United States of a self-conscious aboriginality or indigenousness has had enormous impact on contemporary art practice.[1] To varying degrees, aboriginal people have achieved economic, social, political, and cultural sovereignty. In particular, the artistic practice—the work—of the artist has played a significant role in articulating a modern identity, with incisive works and methods that address this new attitude in a complex and contradictory world. The indigenous contemporary artist is now viewed as a complex individual who has matured within highly charged social, historical, and political frameworks, inside and outside of tribal structures. Indeed, such artists can be viewed as a "new tribe," working and enjoying life through an intercultural perspective from the margins. These emerging artists, with their critique of modernity, are a phenomenon of a period that runs parallel with the so-called postmodern, but their attitudes and artistic practices, I would argue, should be characterized instead as a condition of the *post-reservation*.

In my examination of the conditions out of which today's practices arose, I make a distinction between what I call the reservation and post-reservation periods. These two conceptions, roughly equated to the colonial and postcolonial, signify the complex and traumatic relations between the original inhabitants of North America and the European newcomers, and help frame this discussion. Although my essay focuses on Canada, the U.S. narrative offers many parallels.

In Native North America, modernity's universalizing assumptions—bureaucratization, rationalization, socialization, and compartmentalization—were embodied in the colonial state and the federal government's policies imposed on aboriginal people. During the reservation period, from the late eighteenth to the mid twentieth century, certain cultural expressions flourished while others suffered a gradual decline because of disuse or outright prohibition. In the late nineteenth century, ceremonies such as the Sun Dance and the potlatch were effectively outlawed. The post-reservation period, however, brought a remarkable shift in aboriginal people's resistance

to and liberation from a system of government control. As a consequence, aboriginal people across Canada fought to regain long-denied rights and freedoms.

The reservation period roughly coincides with a period of European conquest and domination, beginning in the mid eighteenth century and lasting until World War II. It began when the British defeated the French in 1760 to take control of North America; the British had already set up a colonial office in New York, complete with its first Indian commissioner, which led to the first Department of Indian Affairs; and, in 1763, the Royal Proclamation outlined the colonial power's relationship with aboriginal people, including the mention of lands "reserved" for Indians. Over the next one hundred years, several land surrender treaties further ensured a complete shift in power as British colonial rule took hold.[2]

With the confederation of Canada's provinces in 1867 to form the Dominion of Canada, the new government passed the first Indian Act, which consolidated previously existing laws. The Act was intended to extricate aboriginal people from their traditional ways of life, thereafter to be modeled on the European ideology of modernity. As a result, the Indian body politic was now completely dismembered: the church ensured the spirit was split from the body; the children were taken from their families and educated in military-style boarding schools; and the sick were segregated and removed to hospitals for treatment. During the reservation period, most aboriginal people lived in reserve communities, and the federal government dealt with them collectively through segregated institutional structures. The reserve became the key component of an assimilation policy that had multiple purposes, including to assimilate yet segregate Indians from the Euro-Canadian population and from other bands/tribes[3]; to extricate them from their cultural traditions and "save" them from vices of the outside world such as alcohol; to facilitate the confinement of nomadic people; and to effect the transformation of aboriginal people into productive, self-reliant, and God-fearing citizens. Tribal- or self-government became only a memory as the federal government took control and instituted a new model. Yet far from being completely victimized, aboriginal people not only adapted to their

new conditions but also continued their traditional practices, albeit in a clandestine fashion. Thus, within a colonial framework, isolation did provide a sanctuary. Nonetheless, the policies of the reservation period subjected aboriginal people to genocide, economic exploitation, cultural decimation, and political exclusion—an assimilation experience vastly different from that of settlers who came from various parts of Europe.[4]

The time following World War II can be described as the post-reservation period. Aboriginal people began working together across the country to form political organizations, such as the North American Indian Brotherhood, and to change the conditions under which they had long been subjected. Previous attempts to establish nationwide aboriginal political organizations had been essentially controlled by the government.[5] The return of World War II aboriginal veterans reinforced the burgeoning political process, as they actively contested the racist legacies of colonialism. Eventually, their efforts yielded results. In 1951, for example, the government made several amendments to the Indian Act, lessening certain restrictions. First Nations across the country began to gain greater control over their reserve communities. In addition, more aboriginal people began moving into urban centers to search for work and escape the poor conditions of reserve life. On every scale, aboriginal people began asserting the concept of aboriginal rights, which Menno Boldt interprets as "sovereignty": "rights deemed to be held by the indigenous peoples of Canada by virtue of their ancestors' original and long-standing nationhood and their use and occupancy of the land."[6] By the 1960s, aboriginal people were energized by issues of land claims, self-government, and autonomy, and vigorously affirmed their cultural identities, while demanding recognition from the larger society.

The entry of contemporary Native artists into the art world in the 1960s introduced them to the hegemony of the culturally distinct and different discursive practices of modernism and postmodernism. Modernism, it became evident, meant an exclusive belief in the purity of art and the disappearance of the artist's (ethnic or cultural) identity; both were important tenets promoted at a time when the new Native artist was beginning to af-

firm his or her *aboriginal* identity. To be a modernist meant being progressive and liberated from traditional practices and the demands of everyday life. Such practitioners were not conservers of culture but innovators. Modernism expounded a belief in art's autonomy and separation. Postmodernism, on the other hand, offered strategies of resistance, articulation, and empowerment. Postmodernists sought to connect art with social and political issues, and critiqued modernism's universalizing meta-narratives, arguing instead for the viability of local narratives. They objected to the hierarchical positioning of Western art over other world traditions, asserting that Western art is in effect another "other" in a theater of others. Indeed, art historian Hans Belting writes:

> I must again insist on the initial argument that the rhetorical figure of speech dealing with the end of art history does not mean that art or art history is over but that, both in art and the discourse of art history, we can foresee on the horizon the end of a tradition whose familiar shape had become, in the era of modernism, canonical.[7]

Aboriginal people help constitute themselves in the present by the pen and through use of language. Land claims, self-determination, and self-government are strongly articulated. Reclaiming, as an act, sets up new relations with those who illegally expropriated land from aboriginal people. But it also determines certain parameters for tribes regarding inclusion of their own members: the return to traditional forms of kinship identification; the repatriation of sacred and sensitive objects from museums and restoration of their ceremonial use; the reintroduction of aboriginal language; and the social affirmation of being with those who share similar attitudes, beliefs, and values. Language that speaks of rights to "self-determination" and "self-government" refers to how aboriginal people are to institute their power structures of authority and hierarchy—socially, culturally, economically, and politically. Aboriginal people are to determine who they are and how their communities are structured, leading to the larger political notion of "na-

tionhood" as reflected in the term "First Nation."8

The idea of the post-reservation period brought to the foreground the politics of opposition and struggle, and made problematic the key relationship between center and periphery. The "post" in post-reservation not only refers to that time after the reservation period but also and more important, signals the end of total state control, with authority shifting to the bands/tribes. Aboriginal people began leaving the tedium and confines of reserves for the stimulation of urban centers for social and economic reasons; both regional and national aboriginal organizations came into being to protect treaties and treaty rights; aboriginal people began defining themselves based on the ideals of self-determination and self-government; and through the new Canadian Constitution of 1982, aboriginal people were now recognized as having aboriginal rights. In short, as "First Nations" and as "a people," aboriginal people began reclaiming their full subjectivity. At the start of the 1990s, Elijah Harper said "no" to the Meech Lake Accord, an eloquent and poignant gesture of resistance on behalf of aboriginal people that caught the attention of the public in Canada and around the world.9 Yet without the driving force of large political organizations, some aboriginal individuals found it onerous to contest their own positions. Disenfranchised women, for example, did not have the benefit of such organizations; they did, however, manage to find other ways to make known their situations of inequity.

During this period, Native political leadership greatly influenced the thinking and action, and indeed the very possibility, of aboriginal contemporary artists. Artists began to form cohesive groups to address common issues that were aimed at negotiating discursive and literal spaces within the art world. In turn, aboriginal politicians understood the value of using artists and their works to give a cultural identity to their purposes.

To summarize, the federal government enforced draconian policies to rid aboriginal people of their specific identities (a kind of "ethnic cleansing") and impose on them identities acceptable to mainstream society. Assimilation and acculturation were two processes used to accomplish this goal. Despite these powerful forces, aboriginal people resisted—but at an enormous

cost. Throughout the twentieth century, aboriginal political organizations struggled unceasingly to bring about changes to this relationship. But it was not until the post-reservation period after World War II that radical reconstruction took hold, including the increasing migration of people to cities, aboriginal leaders' demands for a new relationship with the federal government, aboriginal communities' control of educational systems and economic development projects, and aboriginal people's assertion of cultural freedom. Aboriginal people began to embrace the arts, both in urban and reserve spaces. (Today, reserves are a continuing reality, as a land base is fundamental to the self-government movement and vital to aboriginal identity.) Power structures shifted, as the federal government with its special relation with aboriginal people saw them take much greater responsibility for their own affairs. Self-government, self-determination, and land claims are now discursive terms that hold significant currency that surpasses the simply postcolonial. The far-reaching ramifications of the changes they represent pervade every level of society—especially the realm of the artist.

NOTES

1. The word "aboriginal" is more frequently used in Canada to refer to Native people, while "indigenous" is more often used in the United States. In addition, in Canada, the term "reserve" is used instead of "reservation" to refer to the lands reserved for Native people.

2. "At first, lands were reserved for First Nations on an ad hoc basis, as demand arose; from 1850 onward, however, beginning with the Robinson Huron and Robinson Superior treaties, provision for setting aside lands for exclusive aboriginal use was incorporated as part of negotiations for the land surrender treaties." Personal comments of Olive Dickason.

3. "Band/tribe" is an equivalent designation: the former is used in Canada while the latter is used in the United States, with some exceptions.

4. Ania Loomba underlines the fact that Europeans as colonizers always held a privileged difference. See Ania Loomba, *Colonialism/Postcolonialism* (New York: Routledge, 1998), 9–10.

5. "Fred Loft, a veteran of World War I, attempted as early as 1919 to establish a nationwide League of Indians. He ran into official opposition, but his league did get going in the prairie west and managed to survive there for a few years." Personal notes of Olive Dickason, 1999.

6. Menno Boldt, *Surviving as Indians: The Challenge of Self-Government* (Toronto: University of Toronto Press, 1993), 25.

7. Hans Belting, *Art History after Modernism* (Chicago: University of Chicago Press, 2003), 7.

8. This term's efficacy and usage in Canada began in the early 1980s to describe differences and relations to the English and French cultures, the so-called "two founding nations."

9. The Meech Lake Accord, created to recognize the French-speaking province of Quebec as a distinct society, had to be ratified unanimously by all the provinces. Elijah Harper, the lone aboriginal member of the Manitoba legislature, took a stand by withholding his vote because he, like other aboriginal people, felt that denial of this status has been endemic to the country's history. The result of his delaying tactic eventually killed the Accord. Aboriginal people, everywhere, celebrated; and Harper became an instantly recognizable figure.

Gail Tremblay (b. 1945, Onondaga/Mi'kmaq), *Strawberry and Chocolate*, 2000. 16 mm film and full-coat, height 22.9 cm. Collection of the National Museum of the American Indian (25/7273). Photo by Ernest Amoroso.

While Tremblay's creation resembles a basket of woven splints from felled trees, the material from which it was made came from the cutting-room floor at film school.

W. JACKSON RUSHING III

MODERN SPIRITS: THE LEGACY OF ALLAN HOUSER AND GEORGE MORRISON

ALLAN HOUSER (1914–1994) AND GEORGE MORRISON (1919–2000) belonged to that remarkable generation of artists whose work after World War II radically redefined what constituted Native American art. Working in different parts of the country and drawing on divergent aspects of twentieth-century art for sustenance, Houser and Morrison produced compelling indigenous modernisms, the complex meanings of which we have by no means exhausted. In particular, they combined certain ideas, techniques, and visual strategies of European and American modern art with an acute awareness of homeland— place, weather, myth, and ritual—to create poetic and enduring works of art.

Houser's *Mountain Echoes*, a bronze from 1986, for instance, employs the reductive essentialism of Henry Moore or Constantin Brancusi to give tectonic form to the Mountain Spirits evoked by the three singers (see p. 52). Similarly, a quirky, vivid, untitled colored-pencil drawing Morrison made in 1995 situates organic shapes related to abstract surrealism in a Lake Superior landscape that is ambiguously deep and flat (see p. 55). Although Morrison's shapes are nonspecific, they are quasi-figurative and appear volitional. The esteemed critic Gerald Vizenor has suggested that they may refer to spirits of Anishinaabe cosmology, such as Mishapishoo, the Underwater Panther.[1]

Allan Houser, *Mountain Echoes*, 1986. Bronze (edition of eight), 102.9 x 63.5 x 31.7 cm. Collection of Allan Houser Inc. © Anna Marie Houser. Photo by Al Abrams.

Likewise, earlier in the postwar period, the Cochiti painter Joe Herrera mixed pottery and textile designs and images from rock art and kiva murals with elements of such modern styles as synthetic cubism and art deco to produce such works as an untitled watercolor from 1951 that reminds us that he worked at the Laboratory of Anthropology in Santa Fe recording pottery designs, and *Indian Motif* (1953), which is both telluric and fragmentary. The archaeological character of *Indian Motif* prefigures later works, such as *Hunter* (1954), which were inspired by sketches he made in 1954 of murals excavated at Pottery Mound, near Los Lunas, New Mexico.[2]

The Santa Clara painter Pablita Velarde, who was Herrera's and Houser's classmate at the Santa Fe Indian School, is best known for fastidiously painted genre scenes of modern Pueblo life. But she, too, experimented briefly in the mid to late 1950s with what her teacher Dorothy Dunn described as "abstract motifs adapted from ceramic designs." Working with homemade dry earth pigments on Masonite, she painted *Thunderknives* (1957), the conceptual space and symbolic forms of which imply both ancient and contemporary cultural practices, as well as the primordial forces and creatures of nature that prompt such practices. Her *Pottery Motif* (1958) is one of the more satisfying paintings of the twentieth century: taut and precise, geometric and organic, aboriginal and modern, it is a pleasure to both the eye and the mind.[3]

The distinguished Cheyenne artist and art educator W. Richard West, Sr., who is best known for traditional narrative paintings, such as *Southern Cheyenne Sun Dance* (1973), also experimented on occasion with abstraction, as in his provocative painting *Apache Devil Dancers* (1969). The purpose of this dynamic painting, West explained to me in an interview in 1993, was to show his students the range of possibilities in art. Houser's son, the sculptor Bob Haozous, articulated a related idea when he stated, "What better role for the arts of any culture than to tell their own people who they are, rather than who they were?"[4] Indeed, this is perhaps the greatest gift our artists can give us—an inspired and inspiring reality previously unknown to us. The critic Lawrence Alloway described this as the revelatory quality of the original work of art.[5]

Herrera, Houser, and Velarde, along with the Yanktonai Sioux modernist

George Morrison, Untitled, 1995. Colored pencil on paper, 26 x 34.3 cm. Collection of Robert and Frances Leff. Photo by Robert Fogt.

Oscar Howe, were all students in the painting studio established by Dorothy Dunn at the Santa Fe Indian School in 1932. Like West, who studied at, and later directed, the art department at Bacone College—Oklahoma's counterpart to Dunn's studio—their subject matter was drawn from the history and contemporary culture of Plains and Southwestern Indian peoples. Morrison's origins, educational experience, and ostensible subject matter were quite different, however, and so it is instructive to review, even if briefly and in general, the careers of Allan Houser and George Morrison.

Allan Houser

In 1914, Allan Houser was the first child born after the Chiricahua Apache were released following twenty-seven years in captivity as prisoners of war. He spent his childhood on his parents' farm near Apache, Oklahoma, and

took what was practically his only formal training in art at the Santa Fe Indian School between 1934 and 1938, after which time, in 1939 and 1940, he painted murals in the Department of the Interior Building in Washington, D.C., which are still extant. In 1948, despite having no formal training as a sculptor and using borrowed and inadequate tools, he completed the majestic *Comrade in Mourning* for the Haskell Institute in Lawrence, Kansas. A figure embodying both grandeur and classical reserve, the sculpture honors Native Americans who died in service during World War II. In 1949, Houser received a Guggenheim Foundation Fellowship in painting and sculpture, and in 1954 the French government awarded him the Palmes Académiques for his outstanding achievement, typified by such works as *Apache Crown Dance* (1953), which shows the Mountain Spirits who appear during the all-important puberty ceremony for girls. From 1951 to 1962, Houser was Artist-in-Residence and art teacher at the Intermountain Indian School in Brigham City, Utah, and from 1962 to 1975 a founding faculty member of the Institute of American Indian Arts in Santa Fe.

In the mid 1970s, Houser firmly established his critical reputation as a sculptor with a series of powerful, direct stone carvings that rely on the scintillating play between highly polished surfaces and more rusticated, archaic ones. Both *Heritage* (1976) and *Proud Heritage* (1976) exemplify well his mastery of materials and his ability to realize dense figure-forms distinguished by grace, strength, and dignity. Prolific and inventive, Houser was the first Native artist to receive the National Medal of Arts, which was presented by President George H. W. Bush in 1992. In the last decade of his life he had solo exhibitions in Berlin, Paris, Tokyo, and Vienna.[6]

George Morrison

Morrison, too, lived a rural life growing up; he was born in 1919 at Chippewa City, Minnesota, an Anishinaabe fishing village on the shore of Lake Superior, east of Grand Marais. After finishing high school, Morrison was able, with the support of the Consolidated Chippewa Indian Agency, to attend the Minneapolis School of Art from 1938 to 1943. Afterward, from 1943 to 1946, he studied at the Art Students League in New York City. A Ful-

bright Fellowship in 1952–53 enabled him to attend the École des Beaux Arts in Paris and the University of Aix-Marseilles in Aix-en-Provence, France, where he made *Antibes* (1953), a knowing analytical cubist pen-and-ink drawing that situates him squarely within the modernist tradition.[7]

But Morrison was fully engaged in the modernist enterprise in art at least as early as 1950, as suggested by a delicate, cryptic, untitled abstraction in pink, black, and gray (1950), which is reminiscent of Mark Rothko's untitled "multiforms" of the late 1940s. Like Rothko's aqueous multiforms, Morrison's mysterious work on paper features amorphous, organic forms that speak indirectly to the shape-shifting quality of nature. In Morrison's image, though, we read a horizon line slightly more than halfway up the picture plane, and we sense, too, that the forms below are perhaps reductive signs for bones, stones, or implements buried in the earth in stratified layers, thus hinting at geologic time, or cultural or psychological evolution.

By the time he joined the faculty of the Rhode Island School of Design in 1963, Morrison had made sophisticated abstractions that exhibited in fields of sensuous color and variegated texture the spontaneous gestures and thickly impasted surfaces characteristic of paintings of the New York School. *Aureate Vertical* (1958) and *Reunion* (1962), for example, make manifest a personalized synthesis of late impressionism with abstract expressionism and tachism, its European counterpart. Informed by painterly precedents but not imitating any particular one, these works constitute an important part of Morrison's unique contribution to postwar abstraction. After many years on the East Coast and in Europe, Morrison returned to his home region in 1970, first to teach at the University of Minnesota and then to "retire" to the studio he built on the Grand Portage Reservation along the shore of Lake Superior.

From his vantage point on the lake, Morrison pursued, like a Zen master, the paradoxically tangible yet ineffable truth of nature in a series of painting and collages of varying scale that seek not to *picture* the visible but to offer an abstract equivalent for the artist's aesthetic *response* to land, water, and sky. *Red Rock Crevices. Soft Light. Lake Superior Landscape* (see p. 58) and *Downward Wind. Cool Pink. Red Rock Variations: Lake Superior Landscape* (1990) are but

George Morrison, *Red Rock Crevices. Soft Light. Lake Superior Landscape*, 1987. Acrylic and ink on canvas on board, 16.5 x 29.2 cm. Collection of the Tweed Museum of Art, University of Minnesota, Duluth; Alice Tweed Touhy Foundation Purchase Fund. Photo by Walter Larrimore.

two of many fine works from this period. Morrison acknowledged that his experience of the lake was "both subconscious and perceptual." He wrote, "One of the notions in my imagination was to capture the infinite variations and changes of moods that pass over the lake at different times." He went on to say, "I am fascinated with ambiguity, change of mood and color, the sense of sound and movement above and below the horizon line. Therein lies some of the mystery of the paintings: the transmutation, through choosing and manipulating the pigment, that becomes the substance of art."[8]

Points of Intersection

Houser's and Morrison's spirituality shared certain aspects. Houser's, as I have written elsewhere,

> ... was bound up in his reverence for the flora, fauna, and land forms
> of the Southwest, which sustained his culture and his art. ...
> Little known until recently are the precious, Romantic water-

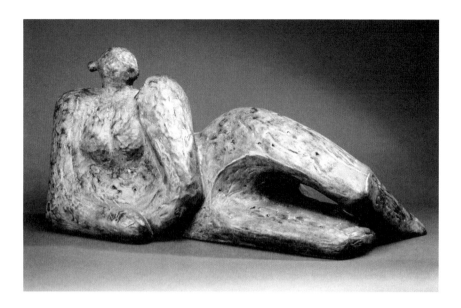

Allan Houser, *Reclining Navajo Woman*, 1992. Bronze, 27.9 x 63.5 x 20.3 cm. Collection of Allan Houser Inc. © Anna Marie Houser. Photo courtesy Allan Houser Foundation Archives.

color landscapes that he probably made in the late 1950s and 1960s. With brilliant washes of color, the distinctive, often dramatic personality of the Southwest, its dazzling sunsets and brooding thunderstorms, is deftly evoked. When we situate these intimate images of expansive horizons next to his sculptures, either narrative or abstract [such as *Water Spirit Bird*, a bronze from 1980], we see that Houser was both a chronicler of life and a visionary visual poet. What he imagined [like Morrison] was every bit as charming and mysterious as what he saw so intently.[9]

As was the case with Joe Herrera and Jackson Pollock, both Houser and Morrison began as regional artists, only later to develop styles that reflected international influences. We can contrast, for example, Houser's delightful watercolor *Apache Back and Forth Dance* (1937), which is notable for its auto-ethnographic content, with his *Reclining Navajo Woman* (1992), a bronze sculpture that

represents, among other things, an Apache artist seeing ancient pre-Columbian sculpture through the eyes of the British modernist Henry Moore (see p. 59).[10]

Similarly, we note the stylistic and conceptual distance between Morrison's youthful landscape "portrait" *Mt. Maude* (ca. 1942) and *Spectator: Busa Fragment,* a paper collage from 1984. Peter Busa, to whom the title refers, was a fellow faculty artist at the University of Minnesota. He was also a friend from Morrison's days on the East Coast and a member of Indian Space, a short-lived group in Manhattan in the 1940s that sought to infuse modern American abstraction with images and ideas derived from Native American art.[11] Together with film and jazz, collage is a medium that bespeaks the twentieth century, and Morrison employed it not to signify the visible landscape, but rather to invoke an "inscape," which the nineteenth-century poet Gerard Manley Hopkins understood as a link between natural phenomena and one's inner world.

Houser and Morrison were thus examples of the critical cosmopolitan. They were among the "country boys" who helped create the liberal culture that flourished in the United States after World War II and is now in peril. Although Houser lived all his life in the Southwest, he did travel in Europe, and he maintained a remarkable library with titles on anthropology, history, art history, and Native and Western studies that informed his art. And even though Morrison lived in France and had his lengthy East Coast sojourn, eventually he felt, in his words, "an inner need to put certain Indian values into my work."[12] Thus he returned to family, to Anishinaabe land and culture, but he carried with him memories of the abstract expressionist milieu in Greenwich Village and the bebop jazz he learned to love there.

Despite their differences in style, we might favorably compare the two artists and their work in other ways as well. Both created, at times, on a monumental scale. Houser's bronze *Resting at the Spring* (1986), for example, is almost eight feet tall. If he can be said to have had a "classical" period, this represents it well: a towering sculpture that perfectly weds form and content by grounding itself in the local even as it strives for universality. Likewise, Morrison's wood sculpture *Lasalle* (1979) is more than twenty feet tall and constitutes an abstract synthesis of many sources, including Northwest

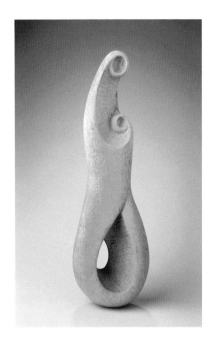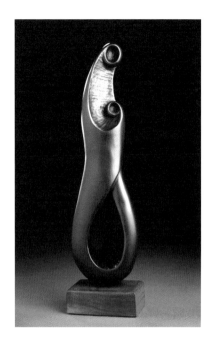

Allan Houser, *Abstract Mother and Child*, 1983. Original wood and bronze (edition of 20), 43.2 x 11.4 x 7.6 cm. Collection of Allan Houser Inc. ©Anna Marie Houser. Photo by Wendy McEahern.

Coast memorial poles and Maya stele. It announces itself with grace and assurance as both aboriginal and contemporary.

Both artists made small, biomorphic abstractions on occasion, as well. Houser's two versions of *Abstract Mother and Child* (both 1983, the first carved in wood and the second cast in bronze), which are each seventeen inches high, are sensuous, decorative, and reductive signs for the bond between mother and child—the abstract essence, if you will, of the mother's protective embrace (see above). Similarly, Houser made two versions of *Amorphous Movement* (1992) in wood and in bronze, each twenty inches high. The two *Amorphous Movement* sculptures reveal their origins in a found object—a desiccated bone or gnarled piece of wood that Houser picked up while hiking in northern New Mexico's rugged terrain. But by cutting holes into the mass, in the manner of Moore and fellow British sculptor Barbara Hepworth, Houser calls attention to "objectness" and therefore, the transformation of the "natural" into art.

Morrison's smaller works, such as his untitled cube of exotic woods (ca. 1984–85), and his *Chiringa Form (Small #1)* from 1987 made from purple-heart and padauk woods, demonstrate that he was a skilled artisan, whose refined sensibilities enabled him to create precious and poignant visual poems from natural materials. He made these, he explained, "for their physical beauty," emphasizing elegant shapes and smooth but tactile surfaces.[13] The cube refers, even if indirectly, to cubism, while *Chiringa Form* is based intu-itively on the Australian Churingas, or totemic forms, that Morrison had seen on display at the Minneapolis Institute of Arts.[14] But in spite of these subtle allusions, the sculptures are purely autonomous works of art, and like Houser's organic abstractions, they remind us that abstract art is not al-ways—or even often—vague, obscure, or hermetic. On the contrary, these objects are literal and specific, artistic imagination made tangible, and they testify with quiet pride to their material existence.[15]

Insistence on authenticity constitutes another point of intersection between these two Native modernists. Please know that by authenticity I do not mean an unmediated cultural "essence" that is manufactured by the visual and verbal discourses of the "ethnographic present." On the contrary, both Houser and Morrison understood their historical moment perfectly well, and they had no hesitation whatsoever about making what we think of as hybrid or transcultural art—although I expect they understood it simply as making contemporary art. That is, *their* contemporary art. In a recent book on hybridity in "world beat" music, the musicologist Timothy D. Taylor defines authenticity as "a sincerity or fidelity to a true self."[16] Similarly, in *Multiculturalism: Examining the Politics of Recognition*, Charles Taylor writes of authenticity, "There is a certain way of being human that is my way. I am called to live my life in this way, and not in imita-tion of anyone else's life."[17] This notion of authenticity as truth to self is also associated with the literary critic Lionel Trilling's book *Sincerity and Authenticity* (1969),[18] and thus I am ascribing to Houser and Morrison the *other* kind of authenticity, the one valorized in postwar liberal culture. We might imagine them saying to themselves, consciously or otherwise (paraphrasing Charles Taylor here), "I am called to make *my* art this way, and although I am free to absorb artistic influences and participate in the visual dialogues of modern and con-

George Morrison, Untitled, ca. 1960. Found wood, 38.1 x 88.9 x 25.4 cm. Collection of Dr. Constantine and Aka Pereyma. Photo by Jonathan Warner.

temporary art, my work is not imitative. It is mine." For Houser, that meant the freedom to work in a variety of styles, represented by the semi-abstract natural-ism of an *Untitled (Drummer)* limestone carving from 1992, or by the resolutely abstract *Migration*, a magnificent biomorphic bronze, also from 1992.

For Morrison, truth to self meant arriving at an abstract style inimitably his own by working his way through a litany of modernist influences, includ-ing impressionism, cubism, surrealism, action painting, primitivism, and col-lage.[19] Here we might consider, among many examples, his untitled found-wood assemblage (see above) or his *Three Surrealist Forms—Automatic*, a mixed-media drawing on paper (see p. 64).

According to the critic Harold Rosenberg, "an artist is someone who invents an artist."[20] Against long odds and before the G.I. Bill (which benefited Joe Herrera), Houser and Morrison invented themselves as artists. An Apache farm boy and a self-described sickly kid from a rural fishing village declared them-selves artists and proceeded to live the life of professional artists, which was not always easy. Fortunately, they were afforded educational opportunities. Wise teachers invested in them, they were awarded Guggenheim (Houser) and Ful-bright (Morrison) fellowships. A network of colleagues helped them earn teach-ing positions, which enabled them to pursue their artistic practice. Granted, they

George Morrison, *Three Surrealist Forms—Automatic*, 1984. Ink, ink wash, and colored pencil on paper, 27.5 x 20.5 cm. Collection of Hazel Belvo. Photo by Robert Fogt.

maximized their opportunities, but we do need to acknowledge the role of teachers, patrons, and educational and cultural institutions in their professional lives.

The Legacy

What, then, is the legacy of these modern spirits? Ultimately, their legacy is the model that their self-invention and quiet but tenacious determination offer young artists. Implicit in this model, however, is the obligation that befalls society at large to establish opportunities and contexts in which emerging Native American artists can thrive. Important exhibitions such as the National Museum of the American Indian's *Native Modernism: The Art of George Morrison and Allan Houser* provide a variety of aesthetic and cultural enlightenment. Even as we celebrate Houser's and Morrison's art and the op-

portunities afforded them, we must acknowledge that Indian youth are suffering—from inadequate housing and health care, from a lack of educational and employment options on rural reservations, from discrimination. As I see it, the legacy of Houser and Morrison, then, is at least in part a challenge to government officials, foundations, philanthropists, and educators, specifically, and to the American public in general: will you dedicate yourselves to social justice and equal opportunity for Native Americans? To my art history colleagues I issue a personal challenge: will you find a place in your collegiate curriculum for the achievements of modern and contemporary Indian artists? As a devoted student of the art of Allan Houser and George Morrison, I was delighted to see the exhibition *Native Modernism* as part of the grand, cathartic inauguration of the Smithsonian's National Museum of the American Indian on the National Mall in the fall of 2004. And yet, I look forward to the day when Native American artists of this stature are given serious retrospective exhibitions in so-called mainstream museums of modern and contemporary art.

NOTES

1. Gerald Vizenor, "George Morrison: Anishinaabe Expressionism at Red Rock," in Truman T. Lowe, ed., *Native Modernism: The Art of George Morrison and Allan Houser* (Washington, D.C.: Smithsonian National Museum of the American Indian, in association with University of Washington Press, 2004), 45.

2. See my essay, "Modern by Tradition: The Studio Style of Native American Painting," in Bruce Bernstein and W. Jackson Rushing, *Modern by Tradition* (Santa Fe: Museum of New Mexico Press, 1995), 61, 66–73.

3. Ibid., 69–70.

4. Quoted in David Revere McFadden and Ellen Napiura Taubman, eds., *Changing Hands: Art Without Reservation*, vol. 1, *Contemporary Native American Art from the Southwest* (London: Merrell Publishers in association with American Craft Museum, 2002), 184.

5. Lawrence Alloway, "The American Sublime," in *Topics in American Art* (New York: W. W. Norton, 1975), 38.

6. For a full assessment of Houser's career, see W. Jackson Rushing, *Allan Houser: An American Master* (New York: Harry N. Abrams, 2004).

7. On Morrison, see George Morrison, *Turning the Feather Around: My Life in Art* (St. Paul: Minnesota Historical Society Press, 1998) and Lowe, *Native Modernism*.

8. Morrison, *Turning the Feather Around*, 168, 170–71.

9. Rushing, *Allan Houser*, 14.

10. Ibid., 47, 58, 143, 146.

11. For Peter Busa and "Indian Space," see W. Jackson Rushing, *Native American Art and the New York Avant-Garde* (Austin: University of Texas Press, 1995), 137–55.

12. Morrison, *Turning the Feather Around*, 135.

13. Ibid., 175.

14. Ibid.

15. "The erroneous notion that only particular objects are sharply circumscribed whereas abstractions are vague and imprecise: On the contrary, any abstraction, no matter at what level, needs precision in order to be usable." Rudolf Arnheim, "Snippets and Seeds," *Salmagundi*, no. 56 (Spring 1982): 170.

16. Timothy D. Taylor, *Global Pop: World Music, World Markets* (New York and London: Routledge, 1997), 21.

17. Charles Taylor, "The Politics of Recognition," in Amy Gutmann, ed., *Multiculturalism: Examining the Politics of Recognition* (Princeton: Princeton University Press, 1994), 30; cited in Taylor, *Global Pop*, 21.

18. See Taylor, *Global Pop*, 21.

19. See Rushing, *Allan Houser*, 23.

20. Quoted in Michael Auping, *Arshile Gorky: The Breakthrough Years* (New York: Rizzoli, 1995), 14.

The author dedicates this essay to the memory of Alexandra "Sasha" Dvorak (1996–2004).

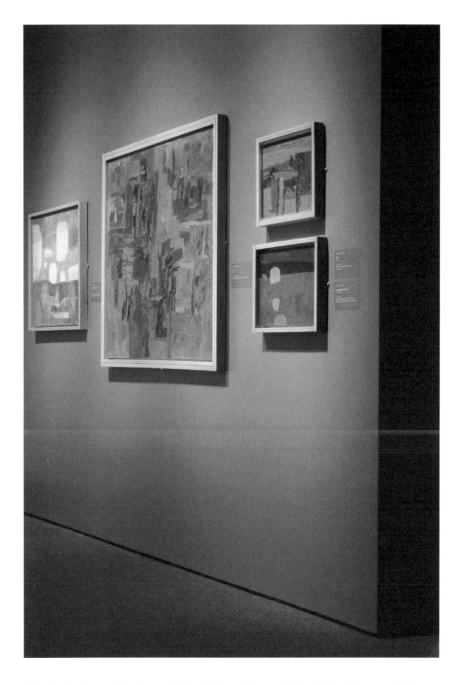

Paintings by George Morrison on display in *Native Modernism: The Art of George Morrison and Allan Houser*, National Museum of the American Indian, Washington, D.C. Photo by Ernest Amoroso.

Adena Pipe. Pipestone, height 20 cm. Ross County, Ohio. Ohio Historical Society, Columbus. Cat. no. 32.

JOYCE M. SZABO

NATIVE AMERICAN ART HISTORY: QUESTIONS OF THE CANON

NATIVE AMERICAN ART HISTORY IS A TOPIC THAT SEEMS WIDE, and in some respects is, but, sadly, in other ways is very narrow. The depth and complexity of the history of Native American creativity from the archeological past to the present are not in doubt. Yet the narrowness of the seemingly vast subject comes in the combination of the words "Native American" within the specific academic discipline of art history. Few colleges or universities in either Canada or the United States offer even a single course in Native American art history, let alone confer graduate degrees in that field; the University of New Mexico and the University of Washington are the oldest Ph.D.-granting institutions in the United States with art historians who specialize in North American art as permanent faculty.[1]

The field of Native American art history—not of cultural studies as part of anthropology, which has had a much longer history—is relatively new.[2] Art history was slow to recognize the aesthetic value of Native American art, while it far more readily embraced the creativity of some other cultures beyond Western traditions, such as Asian and African art

Exclusion of Native American Art
Various factors have kept Native American art from being an accepted part of the art historical canon.[3] Some are based in the identity of early collectors of Native American art—who they were, and who they were not. Native

American and First Nations people, far more than other non-Western cultures, are burdened with romanticizing, stereotypical views that have caused Plains war bonnets, tipis, and beadwork, for example, to be collected by people less interested in them as art than as nostalgic reminders of times past, whether actual historic moments from the eighteenth or nineteenth centuries, or reenacted ones made part of individual memories through television and the Boy Scouts.[4] Another reason for the absence of Native American art from the canon resides in a comparatively late recognition that at least some non-Native avant-garde artists were inspired by Native American art; such inspiration from African and Oceanic art has long been acknowledged. Despite these and many other barriers, Native American art is slowly becoming part of the wider canon of world art history through inclusion in art survey books, references in classrooms, and a variety of other visual means that can ultimately ensure the movement of specific artworks into the realm of iconic masterpieces.

Deconstruction of the art historical canon, or more appropriately *canons*, has been ongoing for at least the past several decades. Such examinations have questioned how canons are formed and why specific groups of artists have been ignored. Feminist art historical inquiries, from the 1970s forward, have explored why women have received so little recognition and other non-Euro-American arts not created by white males have been left out of the major art historical texts.[5] Postcolonial theory has brought some of the other glaring absences to light and has forced recognition of the need for more comprehensive coverage. More recent survey texts for introductory courses in art history have addressed some of these issues in a minimal way by including a chapter, for example, devoted to non-Euro-American, non-Asian arts or by adding a few Native American images to a discussion of American art, particularly during the nineteenth and twentieth centuries. Native American art can be included safely in discussions of the nineteenth and twentieth centuries, after all, because it was during those two centuries that Native arts became admitted influences on Euro-American artists.

Development of Art Historical Canons

Art historical canons have developed in various ways but primarily through the manner in which works of art have been collected, exhibited, and reproduced.[6] Collected works are the ones that are preserved, and photographic reproductions are how those works become more widely recognized. If a masterpiece, for example, were hidden away, would it still be a masterpiece? If museums and private collectors alike did not have photographs of their works available, if those works were never on public display, could they be considered part of the canon? It has even been argued that it is this reproduction, this constant replication, that makes the work of art more dynamic and, in Michael Camille's words, more "communicative and capable of taking on new meaning and significance."[7]

Works included within the art historical canon are those that are good, characteristic examples of the age they represent, those that stand as metonyms for the Italian Renaissance, for example. Or they are individual works apparently of profound innovation and sometimes mystery, the result of the artist-as-genius trope that ensures that the *Mona Lisa* and the ceiling of the Sistine Chapel are included as key monuments of their period. Canons are, then, the body of art historical works that someone must know to grasp major points of the immense field of art history. Canons exist in other fields, most prominently in music and literature, and the same defining factors govern their formations. Given the potentially contradictory play of individual creators of genius and merely representative works of their era in all three fields of art history, music, and literature, it is the great works associated with creator-genius that have prominence. In studying the art of time periods or cultures in which the individual identities of artists are unknown, the work of art itself stands alone, perhaps being attributed to the "Master of the Long Neck," or some other such appellation developed from characteristics seen in the art. This method allows at least some works by artists who remain technically anonymous to be isolated by stylistic conventions and classified, and thus keeps the artist-as-genius categorization in play. The argument for genius and dramatic innovation, however, cannot be effectively made without comparative material to illustrate how the works of a genius rose above those of his or her contemporaries.

In much Native American art created before the twentieth century, spe-
cific artists' names cannot be associated with specific works, although indi-
vidual characteristics can often be perceived. Surprisingly, little work attempting
to isolate individual artistic styles has been done until recent years. Roman-
ticism has impeded such study, for the recognition of individual creativity
destroys the perceived timelessness of the culture-as-creator approach that
has dominated the study of Native American arts, particularly given the ear-
lier foundations provided by the field of cultural anthropology. The iden-
tity of the culture or of a separate geographic or culture area as artist has
also been effectively used to market the work of innovative artists without
giving up the perception of a controlling cultural aesthetic that limits what
an individual artist can or cannot do.[8] Often when individual masterpieces
that break from perceived tradition appear in Native American art, the artist
as genius remains anonymous. Even applying these obvious Western-ori-
ented categories of artistic genius and making judgments of what "good"
representative examples of art from a specific era or location might be are
Western-oriented biases; they are of the Western-controlled world of mu-
seums and academia. Dominant values, including aesthetic ones, have long
been those held by non-Native people. Canons are created by people and
institutions in power.[9]

The Canon of Native American Art

The question of the development of a canon of Native American art as-
sumes the presence both of masterpieces and representative works. Some
works of Native American art stand out, to follow George Kubler, as prime
objects; they remain today as singularly striking examples of long-past cul-
tures.[10] The eight-inch-tall *Adena Pipe* (see p. 68) is one such sculptural work.
Created by someone from a culture known to archaeologists as the Adena
who flourished in the Ohio River Valley approximately eighteen- to nine-
teen-hundred years ago, the pipe presents a standing male figure rendered
in great naturalism. His knees bent and his hands by his side, the figure wears
a loincloth on which a serpentine pattern appears on the front and a feath-
ered bustle on the back. His roached, textured hair and the rounded face

Aerial view of *Great Serpent Mound*. Adams County, Ohio. Photo by Major Dache M. Reeves. PI32II

and open mouth add to the figure's lifelike quality. The great naturalism and unique nature of the pipe have placed it in the art historical canon, both of general world art history as it is currently being taught in some colleges and universities throughout North America, at least, and the more focused canon of Native American art history itself. It is unique. Other pipes from the same era are generally unadorned tubular pieces. Thus, the *Adena Pipe* fits the category of works often included in canons as those created by a master or genius, despite the fact that, in this case, the artist is not known to contemporary viewers by name, but rather by archeological designation and location of discovery.

A second archaeological example, also from the Ohio River Valley, underscores the importance of connection to twentieth-century art created by non-Native artists. While many students might initially be surprised that Euro-American artists Robert Smithson or Nancy Graves were centuries behind in their creation of earthworks, others who are better versed in the history of Native North America know that earthen mounds were created as effigies of animals and humans in the Great Lakes region at least one thousand years ago. The most famous of these effigy earthen sculptures is *Great Serpent Mound* in Ohio (see above). The "snake" form undulates for

nearly twelve-hundred feet with the mounded earth today averaging four feet in height. Long thought to be coeval with the *Adena Pipe,* more recent carbon-14 dates place it closer to 1070 C.E. Even the descriptor as a serpent has come under question because the new date aligns closely with that of the supernova of the Crab Nebula that occurred in 1054 and the appearance of Haley's comet in 1066. Rather than the head and tail of a serpent, the mound might, then, represent a comet flashing across the night sky. The cosmological associations may also be connected to views across the undulations of the mound that may align with solstice and equinox sunrises.[11]

These two works from the ancient Eastern Woodlands are prime examples of creativity highlighting two different types of sculpture, one stone and one earth, one small and one large, one for personal use, even if in a ceremonial context, and one capable of being seen completely only from great height and possibly not made for human viewing at all. Each, however, suggests the connection of its makers and users to spiritual powers. While general art history survey texts may not include both of these works, one or the other of them often is.

Older, pre-European contact works have a strong allure and, to those with particularly romantic leanings, offer untainted examples of the abilities of Native artists. While these two works are undeniably great, they also fulfill a need that many viewers have concerning the mystery of ancient mound-building cultures. That one is a pipe also fits securely within a generalized discussion of the importance of tobacco smoking as ceremonial for indigenous people, whether it was always so or not. But something else here resides in the rendition of the figure, for this is a preeminent work of sculpture. Its naturalism, while seemingly at odds with the mystery, allows contemporary viewers to have a sense of familiarity with the people who made and used the pipe. Portraits of people from distant cultures provide us a sense of connection to them, whether representative or not. The same perceived recognition—that we are given a window onto a world long passed—goes a significant distance in explaining the prominent place in the canon of Native American art history that other representational imagery from the archaeological past holds, including Mimbres ceramics from the

Southwest that show a woman playing with a child (see below) or a potter at work. These are spectacular paintings, but so are some of the Mimbres geometric designs which are less frequently illustrated in survey texts.

The *Great Serpent Mound* is also mysterious, but its inclusion in surveys probably has a great deal to do with how an instructor and a group of students not well versed in Native American art can make a connection to this earthwork; it offers immediate comparison to other earthworks that will appear within the same volumes when their authors reach later twentieth-century American sculpture. Familiarity makes the *Great Serpent Mound* more accessible; it fits more readily within established concepts of modern art history and simultaneously allows entry, seemingly, into the world of ancient Native peoples.

In examining what works appear in world art textbooks as well as in texts devoted specifically to Native American art history, other constants are apparent. Often a Plains hide painting is included, and comparison offered to works made by George Catlin or Karl Bodmer during their 1830s travels

Mimbres Classic Black-on-white Bowl. Baca Ruin site. Mimbres Photographic Archive #820, Maxwell Museum of Anthropology.

throughout the region. Discussion here centers on differing systems of representation and reasons for their creation. The Southwest might be represented by a Diné blanket or rug, the Northwest Coast by a crest pole.

Works that do not fit neatly into readily recognizable categories, that are often discussed as liminal or on the borders either between time periods or culture areas, are not often included in the canon of Native American art history. If asked to consider Native American art, many people would think immediately of works from the Plains, the Southwest, and the Northwest Coast, and these are often the areas from which works found in art history surveys originated. Other areas rich in visual expression would be included, of course, depending upon the complexity of the coverage provided. One of the least frequently represented is art from the Plateau region. Even in texts devoted specifically to Native American art, the Plateau is sometimes discussed as a pastiche of the areas around it, offering nothing of its own. A Nez Perce shirt, technically from the Plateau, would be less likely to appear than a similar Crow shirt from the Plains, and a Nez Perce cradle might be overshadowed by one from the Great Lakes.

Occasionally more contemporary works are included in world art survey texts. Sometimes a Studio-style painting from the first half of the twentieth century appears, perhaps one by Gerald Nailor or Pablita Velarde; Nailor's untitled presentation of potential buyers inspecting a Diné rug is Studio in style, with its firm linear outlines and flat application of color, but not in subject matter, for it depicts outside intrusion—and in a sarcastic manner at that. Nailor's painting, like a work by Velarde, might be included to meet the writer's desire to allow humor as well as works by women to be recognized parts of the history of Native American painting of the era. Other works may appear in multiple venues because they meet an agenda, perceived or actual, of authors to place the artist or subject within a constructed argument. A self-portrait by the Kiowa artist Wohaw is often discussed as an illustration of the artist struggling to choose between his old life and a new one, a struggle that Aaron Fry has recently suggested is far more in the minds of contemporary writers than it is in the artist's image.[12] If work from the midpoint of the twentieth century is included, it might

T. C. Cannon (Caddo/Kiowa), *Osage with Van Gogh* or *Collector #5*, ca. 1980. Woodcut after painting by the same title, 64 x 51 cm. Courtesy of the Heard Museum, Phoenix, Arizona. Photo by Craig Smith.

well be one by T. C. Cannon (see above), as a recent slim volume devoted to twentieth-century American art did.[13] Occasionally a more contemporary work, most frequently James Luna's *Artifact Piece* from 1987 (pp. 84 and 85) or Jaune Quick-to-See Smith's *Trade (Gifts for Trading Land with White People)* of 1992, appears. But Native modernism has little representation in these texts.[14]

Works appear in these texts for various reasons, including their impact on other art, their prominence in exhibitions, their collection history, and the stories the writers can tell about them. They also appear, especially in recent years, if they seem to fit or allow elaborate theories to be applied to them; sometimes it seems that authors force works to conform to theoretical models rather than use theory to explicate what is actually there.

From the late 1920s forward, exhibitions have had an increasingly important role in the perception of Native and First Nations works as art and, hence, an area of study for art history. In December 1927, the *Exhibition of Canadian West Coast Art: Native and Modern* opened at the National Gallery of Canada. As its title suggests, the show included both Native and non-Native art and sought comparisons between them. In the States, two important early exhibitions of American Indian art held in New York—the 1931 *Exposition of Indian Tribal Arts* at Grand Central Galleries, which billed itself as "the first exhibition of American Indian art selected entirely with consideration of esthetic value," and the better known *Indian Art of the United States* held at the Museum of Modern Art in 1941—encouraged collection by serious art audiences. The former exhibition was sponsored by the College Art Association, providing an important seal of approval, while MoMA's locale as the site for the latter sent a clear and immediate message. Contemporary art, as well as art from both the archaeological and the more recent past, was included in each exhibition; paintings on paper from the South‚west were given particular prominence in the 1931 show, and modern Native art for modern living was the focus of a section of the 1941 exhibition.[15]

Impact of Exhibitions, Auctions, and Marketing

The period between 1931 and 1941 saw some other developments that would ultimately impact the formation of an art historical canon in Native American art. While sales including Native American art held at major auction houses like Sotheby's were rare before the 1970s, there were exceptions. One occurred in 1937, when the works of private collectors Mr. and Mrs. Charles Baisley were sold at the American Art Association–Anderson Galleries under the title "Art of the American Indian."[16] As auctions increased, so, too, did prices. A Chemehueve basket that would have brought between five and sixty-five dollars at the 1937 auction was sold for more than twelve thousand dollars in the early 1980s, and prices continue to soar. Such sales bring greater exposure and greater desire for collectors to increase their holdings. Collectors with major holdings are then courted by museums, catalogues created or articles written featuring reproductions of pieces from the

collections, and additions to the art historical canon are made.

Other exhibitions in both Canada and the United States from the 1940s to the 1970s increased the visibility of Native art and, in some cases, set the stage for the wider recognition of individual artists by name rather than culture alone. While promotions of ceramics in the Southwest, for example, had made potters such as Maria Martinez of San Ildefonso Pueblo and Nampeyo from Hopi known and had encouraged potters to sign their names on vessels, a landmark exhibition held in 1974 at the Maxwell Museum of Anthropology of the University of New Mexico in Albuquerque expanded a practice that continues today. Titled *Seven Families in Pueblo Pottery*, the exhibition presented works by various potters from four different pueblos with diagrams of seven family trees providing connections of artists to their predecessors as well as to their descendants. The tiny 7 by 7.5 inch, 112-page catalogue became a kind of Bible for pottery collectors who could readily "authenticate" works from the families. While the catalogue went through numerous printings with different covers, the original cover was modeled on work done by the hard-edge modernist Frank Stella and includes a series of the number 7 rendered in different colors and inset within one another. Through the selection of this modern mainstream American painting, the catalogue visually linked the exhibition and the potters within it to modern art. The family members and the work presented in the exhibition were just as modern as Stella's canvases, but Pueblo pottery had long been seen as premodern, craft versus art, in the days before the era of postmodernism questioned those arbitrary distinctions that clearly carry biases not related to skill or creativity.[17]

Exhibitions of Native American art have increased exponentially since the early 1980s, with 1992 a banner, and undeniably token, year as the five-hundred-year anniversary of the arrival of Columbus was observed. Subsequent exhibitions have focused broadly on culture areas and more narrowly on the art of specific Native nations or individual artists. Such exhibitions as the National Museum of the American Indian's *Continuum: 12 Artists* (April 26, 2003–January 2, 2005) and *New Tribe: New York* (January 29, 2005–April 9, 2006), both at its George Gustav Heye Center in New York City, and

the inaugural *Native Modernism: The Art of George Morrison and Allan Houser* (September 21, 2004–November 6, 2005) at the new building in Washington, D.C., are only the most obvious of many held in college, city, and state museums as well as private galleries throughout North America and, in many cases, in wider global settings. All of these exhibitions provide a foundation and a drive that will expand the canon of art history to eventually include greater representation of Native American art.

There are other, more mundane ways in which works of art become widely recognized, especially through marketing of a great number of objects ranging from refrigerator magnets to mouse pads and Pendleton blankets. Native American art has been particularly subject to this in ways that suggest uncanny comparisons to the idea of "ownership" of Native people and Native culture that many other kinds of souvenirs carry.[18]

Governmental Approval

The federal governments of both the United States and Canada have had long and continuing impact on the creation and marketing of Native arts. After initially discouraging creative works that expressed Native views and thus ran counter to assimilation, each government began to encourage Native arts beginning in the 1930s as an avenue to greater self-sufficiency for Native people. Two very recent actions, one in the States and one in Canada, also impact wider recognition of Native arts.

In August 2004, the U. S. Postal Service issued stamps titled "Art of the American Indian" (see p. 81). The first issue of these was conveniently timed to coincide with the annual Indian Market held in Santa Fe, New Mexico. Some of the artworks represented on the stamps were surprising ones and, given the vast expanse of geography and of time during which Native artists have created art, the exclusions were also intriguing. The stated aim of the selections, as the text on the back of the page of self-adhesive stamps attests, was to "illustrate the talent, ingenuity, and artistic skills of America's first peoples." Three examples are from the Southwest (four if California is considered part of the greater Southwest), only one each from the Plateau and the Northwest Coast, two from the Great Lakes

Art of the American Indian Stamp Series, © 2004 United States Postal Service. Used with permission. All rights reserved. Written authorization from the Postal Service is required to use, reproduce, post, transmit, distribute, or publicly display these images. Ho-Chunk bag from the collection of the Cranbrook Institute of Science, photo © 1992 The Detroit Institute of Arts.

post-contact period, one archaeological Southeastern example, and one twentieth-century Southeastern Seminole doll. In including a Kutenai parfleche from present-day Idaho rather than a Plains painted container or elaborate beadwork, the selections break with what might be termed a more generally established canon; no Plains work specifically is here while a work from the Plateau is, albeit one that is very much like a parfleche from the Plains. There is also no art from the Arctic or the Subarctic. The lack of focus on the Subarctic is undoubtedly due to political boundaries; the Subarctic lies within Canadian territory and these are, after all, U.S. stamps. The absence of art from the Arctic is not as easily explained. Alaska, at

least, is part of the States, and the Yup'ik and Iñupiat people created and continue to create spectacular art forms.

From the ten images reproduced as Native American art stamps, viewers might assume that only in the Southwest are later twentieth-century Native American artists actively working to create spectacular works of art (although the latest work here is Lucy Lewis's 1969 jar from Acoma); a 1940s rug by Daisy Taugelchee also suggests that, at least at that point, Diné weaving was a vibrant art form. These two mid-twentieth-century examples appear with the oldest work included in the selections, a striking Mimbres black-on-white bowl, thus establishing the longevity of Native art in the Southwest. Only the Southeast achieves something similar in the pairing of a powerfully naturalistic male figure from 1300–1550 with the Seminole doll from the 1930s.

The text accompanying the stamps attempts to gloss over the lack of any work made after 1969: "Creative expression continues to flourish among American Indian artists today. Some still create traditional forms; others are expanding their artistic endeavors in new directions in the fields of painting, sculpture, photography, printmaking, video, and performance art." None of these modern media, however, is given visual form.

The most recent and powerful honoring of a First Nations artist in Canada appears on the new twenty-dollar bill (see p. 93). Its rich design features artworks by the renowned Haida artist Bill Reid. Within the inks of the spectacular bill are images of his massive *Spirit of Haida Gwaii* (1991) and his *Raven and the First Men* (1980). Other pieces of his are here as well, faintly rendered in the background. His works in a more clearly modernist vein, however, including his masterpieces of gold and diamonds, are not here. Certainly if some works of art are reproduced on the face of a twenty-dollar bill, then those works are part of the canon. By extension, are those that are not portrayed not to be part of the canon?

Expanding the Canon

All of these examples, from art included in art history survey texts to exhibitions, and from mouse pads to stamps and currency, increase audience awareness of Native American art. Greater recognition of the creativity of Native artists, both modern and premodern, will, in turn, lead to more indepth study and inclusion in the art historical canon. Currently, with very limited exception, most Native American art that fits into a prescribed canon is that of the timeless, more often than not nameless, artist who can, for many, still reside in some past not connected to the present. Where in art history's histories and the development of the canon do modern artists fall? How do artists attain the position that allows them to enter the hierarchy of art historical acceptance? This is not a question of importance just for Native artists; it applies universally to artists currently creating art. Relatively few living artists appear in surveys of world art. Only a few, such as Christo or Bill Viola, who work in new ways or with new technologies that have no readily recognizable history before the last couple of decades may be included.

Two men are among the most frequently discussed Native American or First Nations artists. Bill Reid, most often represented by his massive *Spirit of Haida Gwaii*, provides opportunity for discussion of the "renaissance" of Northwest Coast art, whether there was a renaissance or not.[19] James Luna may hold another appeal as a slightly "dangerous" bad boy in some of the personas he adopts in his performances.[20] The work most often reproduced is a still photograph from his *Artifact Piece*, in which the artist put himself, dressed only in a loincloth, and some of his possessions on display in a museum. Here, the possibilities for examination of the roles that museums have played in objectifying Native people coexist with an invitation to look at the male body on display and, thus, fulfill another kind of long-held romantic fascination.

From archaeological masterpieces to contemporary ones, the range of Native American art is immense. Slowly, some of these works have entered and enriched the canon of art history, but exhibitions, catalogues, articles, and critiques all need to be opened more widely for modern Native American art, in particular, to achieve the recognition it deserves. This is a canon that can only grow, and it needs to do so sooner rather than later.

Opposite and above: James Luna (Luiseño), *The Artifact Piece*, 1987. Sushi Gallery, performed at the San Diego Museum of Man, California. Photos by John Erickson, courtesy of James Luna.

NOTES

1. Other institutions such as Yale and Columbia may have offered early opportunities to obtain degrees focusing on Native American art, but they did so with specialists in African or Mesoamerican art as the guiding faculty.

2. Janet Catherine Berlo has addressed some of these issues, most recently in her "Anthropologies and Histories of Art: A View from the Terrain of Native North American Art History," pp. 178–92, in *Anthropologies of Art*, edited by Mariët Westermann and part of the Clark Studies in the Visual Arts series (New Haven: Yale University Press, 2004).

3. Although I am focusing here on the aesthetic traditions of North American Indians, the same problem of exclusion from the art historical canon is, of course, applicable to the art of all indigenous peoples of the Western Hemisphere.

4. Excellent studies of aspects of this phenomenon exist, including Phillip J. Deloria, *Playing Indian* (New Haven: Yale University Press, 1998).

5. See, for example, Griselda Pollock, *Differencing the Canon: Feminist Desire and the Writing of Art's Histories* (New York and London: Routledge, 1999).

6. Michael Camille, "Rethinking the Canon: Prophets, Canons, and Promising Monsters," *Art Bulletin* 78: 2 (June 1998): 198–201.

7. Ibid., 199. Ultimately, Walter Benjamin's oft-quoted essay "The Work of Art in the Age of Mechanical Reproduction," pp. 217–51 in *Illuminations* (New York: Schocken, 1969), could be brought into the discussion here. One of many examinations of the Benjamin essay, "Mechanical Reproduction in the Age of Art" by Paul Mattick, Jr., in *Arts Magazine* 65, no. 1 (September 1990): 62–69, raises interesting observations about how Benjamin's words have been used and misused. Neither essay, however, negates the ability of photographs to make works of art more readily recognizable and, therefore, more likely to engender closer examination and enter the canon.

8. Strong examples of this practice can be found in the ways in which the highly innovative baskets of Elizabeth Hickox and Louisa Keyser were marketed. See Marvin Cohodas, "Elizabeth Hickox and Karuk Basketry: A Case Study in Debates on Innovation and Paradigms of Authenticity," pp. 143–61 in Ruth B. Phillips and Christopher B. Steiner, eds., *Unpacking Culture: Art and Commodity in Colonial and Postcolonial Worlds* (Berkeley: University of California Press, 1999); and Marvin Cohodas, "Washoe Innovators and Their Patrons," pp. 203–20 in Edwin Wade, ed., *The Arts of the North American Indian: Native Traditions in Evolution* (New York: Hudson Hills Press, 1986).

9. During the fall of 2004, I conducted a semester-long graduate seminar on the canon of Native American art history that examined whether there was a canon of Native American art history and, if so, how was it being formed, what was included in it, and who had the power to formulate that canon. Examination of works of Native American and First Nations art included in world art survey books as well as in more in-depth volumes devoted exclusively to Native American art indicated that, despite the expanse in time and geography, some of the same works appeared repeatedly, thus supporting the view that a canon is being developed or, in fact, exists for the study of Native American art.

10. George Kubler, *The Shape of Time: Remarks on the History of Things* (New Haven: Yale University Press, 1962).

11. Richard F. Townsend and Robert V. Sharp, eds., *Hero, Hawk, and Open Hand: American Indian Art of the Ancient Midwest and South* (Chicago: The Art Institute of Chicago, and New Haven: Yale University Press, 2004).

12. D. Aaron Fry, "What Was Wohaw Thinking? Double Cousciousness and the Two Worlds Theory in Native American Art History." Paper Presented at the 93rd Annual College Art Association Meeting, Atlanta, Georgia, February 2005.

13. Erica Doss, *Twentieth-Century American Art* (New York: Oxford University Press, 2002).

14. From a recent examination of the more than seven-hundred-page, two-volume work edited by Hal Foster, Rosalind Krauss et al., titled *Art Since 1900*, published last year, I could find only two references to artists connected to Native American art. Performance artist James Luna is mentioned and a work by Jimmie Durham is illustrated, both in a chapter devoted to postcolonial discourse and multicultural debates from the late 1980s.

15. These exhibitions have been examined at length in various publications. See especially Diana Nemiroff, "Modernism, Nationalism, and Beyond: A Critical History of Exhibitions of First Nations Art," pp. 15–41 in Diana Nemiroff, Robert Houle, and Charlotte Townsend-Gault, *Land, Spirit, Power: First Nations at the National Gallery of Canada* (Ottawa: National Gallery of Canada, 1992), and W. Jackson Rushing, "Marketing the Affinity of the Primitive and the Modern: René d'Harnoncourt and 'Indian Art of the United States,'" pp. 191–236 in Janet Catherine Berlo, ed., *The Early Years of Native American Art History* (Seattle: University of Washington Press, 1992).

16. Thomas E. Norton, *100 Years of Collecting in America: The Story of Sotheby Parke Bernet* (New York: Harry N. Abrams, 1984), 127.

17. The practice of naming artists and families has continued. Rick Dillingham's *Fourteen Families in Pueblo Pottery* (Albuquerque: University of New Mexico Press, 1994) enlarged both the number of families and the size of the volume itself to a handsome 10 1/4 by 10 1/4 inch, 289-page color-filled book. Many other books focus on individual potters as well as individual pueblos. In his foreword to *Fourteen Families in Pueblo Pottery*, J. J. Brody discusses the phenomenon that the *Seven Families* exhibit had created twenty years before Dillingham's *Fourteen Families* was published. Brody notes that Pueblo pottery had become "an established if minor fine art" by the early 1920s, when Maria Martinez began to sign her pots (p. xvi). Even if some collectors considered Pueblo ceramics to be fine art, a modernist connection did not follow. The importance of the message carried by the selection of an image modeled on a Stella painting on the *Seven Families* catalogue cover, whether the modernist connection was intended or not, is not negated by these observations.

18. See Ruth B. Phillips, *Trading Identities: The Souvenir in Native North American Art from the Northeast, 1700–1900* (Seattle: University of Washington Press; Montreal: McGill-Queen's University Press, 1998).

19. On this point, see the discussions in Karen Duffek and Charlotte Townsend-Gault, eds., *Bill Reid and Beyond: Expanding on Modern Native American Art* (Seattle: University of Washington Press, 2004).

20. See Lara M. Evans, "'One of These Things Is Not Like the Other': Works by Native Performance Artists James Luna, Greg Hill, and Rebecca Belmore," Ph.D. diss., University of New Mexico, August 2005, for further examination of Luna's works and some of the roles he assumes.

Robert Davidson (b. 1946), *kugann jaad giidii*, 1983. Acrylic on paper, 76 x 56 cm. Collection of the artist. Photo by Robert Keziere.

CHARLOTTE TOWNSEND-GAULT

THE RAVEN, THE EAGLE, THE SPARROWS, AND THOMAS CROW: MAKING NATIVE MODERNISM ON THE NORTHWEST COAST

Robert Davidson: The Abstract Edge, an exhibition of abstract paintings—*Haida* abstract paintings on canvas, paper, and drums, made over the past three decades—demands that another look be taken at modernism on the Northwest Coast.[1] The questions raised by this exhibition, which opened at the University of British Columbia's Museum of Anthropology in June 2004 and is being circulated by the National Gallery of Canada through May 2007, are familiar. Can work that is, in content and intent, culturally circumscribed be "modern art"? Can "abstraction" be a meaningful endeavor outside of modernism? And, as always, who decides?

The artists considered here assume their own right to decide, an agency significantly linked to their hard-won social and political rights as Native people in Canada today. It is a linkage that makes what may look like rather conservative, if not anti-modern, work politically radical. When Native pasts and traditions both material and incorporeal are being increasingly and avidly protected, it is intriguing to find artists deploying the new—ostensibly a threat to the old—in the defense of these pasts and traditions. In certain "traditional" masks of the Northwest Coast, eminent historian of modern art Thomas Crow finds "an awe-inspiring imaginative reach [which] was actually a reproach to the creative capacities of the category-bound West."[2] Work made over the past three decades by artists as diverse as Bill Reid (Haida) and Debra and Robyn Sparrow (Musqueam), as well as Davidson,

also reproaches. To see it as being more "traditional" than "innovative" is to miss its modernist oppositional potential.[3]

Always in troubled relation to the past, always questioning the present, always both desiring and querying the autonomous status of the work of art, always anxiously self-critical—these were among the defining and un-restful characteristics of modernism through a large part of the twentieth century. A prevailing notion of the cultures of "the Northwest Coast" as havens of tradition that somehow missed out on modern and went straight into less-stringent postmodern overlooks the defining significance of these characteristics for Native art in British Columbia. Settler colonization has much to answer for in many parts of the world but, in North America par-ticularly, its consequences are inseparable from the modernizing project. The disruptive forces of industrialization and urbanization provoked—and now, with what is understood as globalized capitalism, help maintain—modern art's turbulent and paradoxical critique of the very conditions that have en-abled its experiments. Because modernity inevitably weakened the valued ties that bind individuals to their cultural pasts, the ideal of freeing individuals could simultaneously contribute to the sources of their oppression. For these reasons, many argue that modernism—roughly, the cultural response to the conditions of modernity—persists even though it may take different forms in different places. In urban British Columbia, for example, it has allowed a degree of freedom and artistic license that often runs counter to the con-straints implicit in identifying with the protocols and traditions of a spe-cific First Nations culture. It is worth asking whether these constraints are a protective response to modernity as well as to colonialism.

Contemporary Native artworks stand in complex relation to the past: mourning, restoring, reconfiguring. At the same time, they aspire to estab-lish their own independent terms. This is a variant of the attempt "to as-sert a measure of integrity of purpose in the face of the social and economic forces defining and insistently compromising the status of art," in Alex Potts's capsule version of autonomy.[4] In making such an attempt, these artists are insisting on a relationship—in some cases marked by their use of Native names, certainly marked in the appearance of their work—to the social and

economic forces that gave rise to the artistic conventions of the past. They are simultaneously embroiled in the sociopolitical situation of their own day, which defines how they present their work and how it is currently received. And in the highly charged political atmosphere of British Columbia today, it will be received very differently from how it would be in New York, say, or Paris. Such are the tense relations they must take on and about which they may be ambivalent if not actually critical, or even angry.

This is pretty much the definition of modern art articulated by Theodor Adorno, the critical social theorist.[5] It seemed radically paradoxical to Adorno, and so it is today. The paradox intensifies where these norms are coming both from within communities defined by ethnicity and from the "non-communities," bounded neither by place nor cultural tradition, of modern art. That is to say the Native artist, wanting to draw on his or her own culture, has to negotiate its protocols concerning what may be represented in public and what may be construed as disrespectful or misappropriative. And then there are the protocols of a modernist discourse that would establish independent criteria for their work. The essays on George Morrison and Allan Houser show this process in action: "walking in two worlds," as Gail Tremblay expresses a familiar formulation in her contribution to *Native Modernism. The Art of George Morrison and Allan Houser* (2004). Arguing with both is what the artist's process also often amounts to.

It may be objected that these are the battles of a modernist yesteryear, that modernity has now gone global and been commercialized, and that the real hegemony is that of the neo-liberalized market to which all other forms of institutionalization are subservient. The trouble with this objection is that it allows all sorts of indicators of tradition to be read as signs of cultural repose, of complacency and profit on the part of producers, their audiences, and collectors, rather than as part of a very real and necessarily continuing power struggle. For example, contemporary uses of Native names might be clues to what modern has meant on the Northwest Coast. In indigenous societies, names—inherited or acquired during a lifetime—are about belonging to a system of relationships and values. Used now in an intercultural society such as British Columbia's, they identify a First Nations

individual, declare difference within the system of the art world, and take on wider systemic discrimination and racialized politics. So Adorno's paradoxes are reanimated in 2005: the objections that still confront Robert Davidson, guud san glans (Eagle of the Dawn), as he attempts to make modern, abstract, Haida paintings; the uneasy status of the woven robes-turned-hangings of the Musqueam weaver Debra Sparrow, intended as lovely, autonomous things, intended also to be critical interventions; the perpetual fascination over Bill Reid that began in the 1960s—could he be both Haida and modern?

These artists represent varied circumstances, but what they have in common is that they simultaneously use and query the limits of Haida or Coast Salish permissions while they avail themselves of modernism's license to critique restrictive norms and expectations and devise exit strategies from the Euro-American stranglehold.

The Raven

Yaahl sgwansung, translated as "the Only Raven," was one of Reid's several given Haida names. The Raven is a West Coast version of Coyote, a trickster figure, both creative and disruptive. Reid, who died in 1998, helped make Raven legends popular all over again in his own time. Listen to the modern artist's authority with which Reid recast his lineage rights to the Raven to suit himself: "I have created the Raven in my own image over the years and insist that mine is the version of this personality that is correct, well, at least it is correct as far as I am concerned. It suits my own attitude to the world and its people to believe that the Raven is this completely self-centred, uninvolved bringer of change, through inadvertence and accident and so on."[6] One of Reid's innovations was to make a close study of Haida visual tradition and in doing so recover facility with a culturally specific visual language. Another was to take the figures off the poles, away from the box facades, and make freestanding sculptures. His sculpture The Raven and the First Men (1980) is a creation story in more than one sense—both the artist and the Raven are at work. Its work is perpetuated by its appearance, along with The Spirit of Haida Gwaii (1991), on the Canadian twenty-dollar banknote (see p. 93).

The Canadian twenty-dollar bill bears on its obverse images of *The Raven and the First Men* (1980, left) and *The Spirit of Haida Gwaii* (1991, right) by Bill Reid (1920–1998). First issued 2004.

The Eagle

Both Reid and Davidson have made it clear that they are searching for ways of extending what they take to be Haida style, the Haida way of doing art. And yet the recent exhibition of work, mainly paintings, *Robert Davidson: The Abstract Edge*, is situated in the middle of a discussion often set *against* extension. Put another way, work and installation reiterate the definition of "Native" through some idea of the "past," as promulgated by many exhibitions of Native art, if not by the art itself, for more than a century (recall the National Gallery of Canada's 1927 exhibition *Canadian West Coast Art: Native and Modern*). One of the tensions, made visible in the installation for *The Abstract Edge*, is the addition of a canoe paddle and two bentwood boxes, highly regarded examples of nineteenth-century Haida work. They are there to answer the question: how is it clear that this is *Haida* abstraction and not some other kind? The

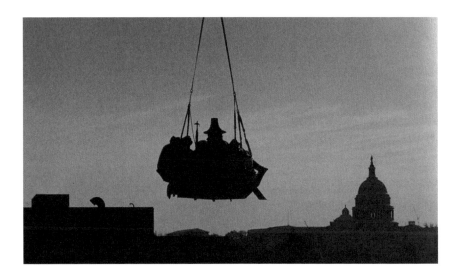

Bill Reid's sculpture *The Spirit of Haida Gwaii* (1991) being lowered into place at the Canadian Embassy, Washington, D.C. Photo by George Febiger.

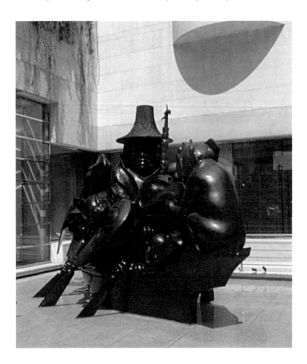

Bill Reid's sculpture *The Spirit of Haida Gwaii* (1991) installed at the Canadian Embassy, Washington, D.C. Photo courtesy of the Canadian Embassy.

boxes give a kind of reader's guide to the old language. The term "language" as a way of referring to the organizing principles of the conventionalized style of Northwest Coast peoples was put into circulation by social anthropologist Claude Lévi-Strauss.[7] Linguistic analysis was the basis of the structural anthropological analysis that he applied, with significant consequences, to Northwest Coast art. It was taken up and elaborated upon by Bill Holm and Bill Reid. For Davidson himself, the idea of a deeply rooted language is part of what he calls the Haida "pool of knowledge."

Just this is also the culture trap. These fabulous old pieces perpetuate the culture-as-visual-phenomenon (to which many have drawn attention), the consequence of too much ocularcentrism, or of so much looking that the viewer is at risk of turning a blind eye to ideological and political formations. This kind of looking and visual defining of culture have had some unforeseen results, one of which is the failure, perversely, to notice the defining criticality, and self-criticism, of the work. The use of the word "abstraction" may itself be a distraction, unlikely to attract the attention of the art world's cognoscenti in the early twenty-first century. But where is the critique, the opposition to prevailing social and political orders implicit in modern art's formal experiments? It has become a commonplace charge that Native art has turned itself into a consumerist spectacle in a globalized economy of thousands of cultural spectacles rather than being a critique of any such thing. Far from opposing them, Davidson's work, highly sought after by collectors, seems to satisfy the desires and demands of the haute bourgeoisie.

Part of the answer lies in the work of which Davidson has said: "I'm at a crossroads right now where I've recycled the ideas of my teachers, of the old pieces, of the old examples I've been studying. My challenge is to go beyond those recycled ideas and create a new vocabulary for myself. . . . Now I'm experimenting to see how far I can push my own understanding."[8] Manifestly, the paintings—*kugann jaad giidii* (see p. 88) or *Southeast Wind* (see p. 96), for example—partake in the abstraction discourse only on their own terms, which are rather particular and limited. Limited that is, by their references to the abstracting devices of what those who belong to it defend, in important respects, as a bounded culture. The repertoire of forms—acute organic

Robert Davidson (b. 1946), *Southeast Wind*, 2004. Acrylic on canvas, 152.4 x 101.6 cm. Collection of the artist. Photo by Robert Keziere.

angles and recurves slicing between figure and ground—are familiar constituents of Haida style. Forms and lines are not allowed to blossom but are poised like coiled springs constrained by the framing edge, reminiscent of the restraining frame of a box front or drum. Can we not find in his insistence on his own terms—precisely because his extensions are confined to those licensed by the dictates of earlier forms—a critique of a free-form or culture-free abstraction? And, if so, is he not also acting as a critical modernist should?

But Davidson has further ambitions. By making people look at Haida art differently, he shows his opposition to how they look at the Haida. Inventive exploration of the Haida visual language is closely connected with the restoration of cultural and social health to the Haida people. "As we re-

claim that knowledge—reclaim the names, the songs, the dances, the crests, the clans, the place of chiefs in Haida villages—it's gone the whole gamut to reclaiming the land. They're all one."9 And so he tacitly invokes devastating colonial relationships, and the numerous projects by the Haida to recover from them—language recovery programs, the repatriation of ancestral remains, new cultural institutions, comprehensive land claims for Haida Gwaii. He also invokes what only a Haida person can invoke, namely, rights—constitutionally guaranteed—based on race. This is something more than the politics of positioning familiar from much recent art's institutional critique. It is actually an attempt to change the rules of modern abstraction. Extending rather than breaking from a tradition, he continues the formal inventiveness of his predecessors. Continuity is political. Simultaneously, he avails himself of modernism's capacity to make anew, and uses it to get over the recent, catastrophic past. Through abstraction, Davidson is at pains to situate Haida in the present as a resilient and inventive force. He has bought into the idea that new art can do such a thing, and now is extending the capacity of the idea.

Crow

Thomas Crow is interested in the problems of interpretation that are at the heart of modern art history. And Crow is here not because of his name—well, only a little bit because of his name. He is made to stand, metonymically, for those for whom protecting cultural knowledge, restricting access, and withholding translation interfere with the untrammeled play of art historical intelligence. In *The Intelligence of Art* (1999), a chapter titled "A Forest of Symbols in Wartime New York" is built around a homage to Lévi-Strauss's structuralist interpretation of three formally disparate masks that he believes to be linked by their meanings to the history of the wealth-complex of the potlatch. He reports on how Lévi-Strauss, in *La voie des masques* (The way of the masks), first published in 1975, identifies a structure, based on binary oppositions, whereby masks that are formal opposites—the Coast Salish sXwayXwəy and the Kwakwaka'wakw Dzonokwa—have similar meanings, whereas masks whose meanings are reversed—sXwayXwəy and the

Kwakwaka'wakw Xwexwe—are formally similar.[10] There is no space here to do justice to this ingenious contrivance, but Crow seizes the opportunity it provides to reconsider masks—quintessential primitive foil to the modern—as themselves modern, caught up in a suggestive web of transcultural relationships. He shows his own modern attitude inasmuch as, like Lévi-Strauss, he believes that masks are good to think with—for anybody, from any culture. That they hold particular, restricted significance for the Coast Salish or the Kwakwaka'wakw in no way limits their significance to the interpretative venture. The need for an access code to works of art that is keyed ethnically is anathema. Crow is a modernist because he sees no reason why such things should not be part of his own thought-worlds, sharing the imaginative freedom that makes art important. And Crow writes with the same authoritative outsider's license for which he commends Lévi-Strauss. Their interpretations bring attention to the sophistication of the originals, were evidently inspired by them, and saw no reason not to be. But for cultural protectionists Crow is transgressing in two ways, as Lévi-Strauss had done before him: by his speculative prying into the meaning of the masks and allowing their reproduction in a book which will circulate beyond anyone's control.

Sparrows

The name "Sparrow" marks one of the catastrophic effects of colonialism, obliteration by English naming. The Sparrows, sisters Debra and Robyn, are members of a group of women responsible for the revival of weaving traditions at Musqueam, the community where the Swaihwe is vital. If Lévi-Strauss and Crow were ignorant of, or uninterested in, the protocols of protection, how are the Coast Salish now protecting its value? (Although some people from Musqueam report having greeted Lévi-Strauss's 1973 research trip coolly, they did not succeed then in conveying the protocols to him.) The University of British Columbia's Museum of Anthropology has a number of sXwayXwəy masks in their collection. They were withdrawn from public display at the request of the Musqueam in 1996. By 1998, while the spectacularizing exhibition *Down from the Shimmering Sky: Masks of the*

Musqueam Weaving by Debra and Robyn Sparrow, 1999. Sheep wool fiber, dye, 348 x 154 cm. Collection of the UBC Museum of Anthropology, Vancouver, Canada, Nbz842. Photo by Bill McLennan.

The weaving (left) is shown next to a nineteenth-century Musqueam house post at the University of British Columbia's Museum of Anthropology.

Northwest Coast was showing at the Vancouver Art Gallery, sXwayXwэy—as spectacular as any—was conspicuous by its absence, permission to display having not been granted.[11] Sparrow weavings, however, flanked the entrance to the exhibition. They proudly announced two things: that the city of Vancouver stands on Coast Salish traditional territory, and that important work—equivalent to any mask—comes from Musqueam, but that at Musqueam their own masks are protected from public view.

Not all First Nations consider themselves as represented by the decontextualized poles-as-autonomous-works of art in the Great Hall of the University of British Columbia's Museum of Anthropology.[12] The Sparrows have been key players in readjusting the relationship between the Museum

and the Musqueam, between the modernist, male-gendered hegemony of the former and the latter's modernizing strategies. Thus, in another deployment of these equally, but intentionally, decontextualized woven hangings—in place at the Museum of Anthropology since 1999—their material, texture, and colors disturb the prevailing aesthetic of the time- and weather-bleached poles (see p. 99). By their resistance, they participate in the modernist tradition of opposition to the status quo. The Sparrows do not need the precedent of, say, the Russian Constructivists, but this way of being modern is often overlooked in the attention given to work of this kind under the rubric of postmodern identity politics.

Debra Sparrow, who acts as spokesperson for the Musqueam weavers, has the name Thelaquilwit. It is the woman's version of a name held by her paternal grandfather from whom she received it, but, she has said, "what it meant to us has been lost," a not-uncommon case of enforced cultural uninvolvement. Although I have been arguing that the weavings are modern artworks, the creators of which avail themselves of the modern license to do critical, new things with the old modes, Sparrow insists, "What we do is not art as you know it, but culture as we know it."[13] She prefers to think of the process of weaving and the ways in which the weavings are distributed through the wider culture, including commercial distribution, as a recovery process—of what had been lost and as advertisement for Musqueam culture. Crow—who, in case you were wondering, is not the villain of this piece—would say, I think, that it is not given to artists to direct operations in this way. Artists' intentions are a part, but no more than a part, of the broad set of social, economic, and political factors that must be taken into account in responding to "the intelligence of art." But isn't it exactly here that we find a congruence between these apparently opposed positions? The Sparrows put culture well ahead of art in talking about the significance of their work, while Crow seems to be saying that the reasons for their intelligent autonomy only derive from their cultural matrix.

Reid's accommodation to his Haida-ness gets more attention than his modernity. Davidson's abstractions get the familiar valorizing description meted out to Native art in Canada these days but almost no critical atten-

tion. The Sparrows's weavings—at the airport, at the entrance to the University of British Columbia's Museum of Anthropology—are noted as lovely additions to social spaces but not necessarily as critical interventions into the sociopolitical environment. If there is something amiss here, could it be anti-modernism? These artists have found ways to empower themselves to make autonomous works that they want to have an impact. That they have done so is not always accepted as such within or outside their communities. Race gets in the way. These anxious tensions are in part the consequence of all being implicated in the critical license that modernism has given Native artists to trouble received ideas of "Native," and partly the consequence of the culturally specific restrictions that modernism now has to find ways of tolerating.

NOTES

1. Karen Duffek, ed., *Robert Davidson: The Abstract Edge* (Vancouver: Museum of Anthropology, 2005).

2. Thomas Crow, *The Intelligence of Art* (Chapel Hill: University of North Carolina Press, 1999), 32.

3. For recent discussions of these issues, see contributions in Karen Duffek and Charlotte Townsend-Gault, eds., *Bill Reid and Beyond: Expanding on Modern Native Art* (Vancouver: Douglas & McIntyre, 2004) and Bill Anthes, *Native Moderns: American Indian Painting, 1940–1960* (Durham: Duke University Press, 2006).

4. Alex Potts, "Autonomy in Post-war Art: Quasi-heroic and Casual," *Oxford Art Journal* 27, no. 1 (2004): 46.

5. Theodor W. Adorno, *Aesthetic Theory*, ed. Robert Hullot-Kentor (Minneapolis: University of Minnesota Press, 1997).

6. Robert Bringhurst, ed., *Solitary Raven: Selected Writings of Bill Reid* (Vancouver: Douglas & McIntyre, 2000).

7. See particularly with reference to the Northwest Coast, "Split Representation in the Art of Asia and America," in *Structural Anthropology*, trans. Claire Jacobson and Brooke Grundfest Schoepf (Garden City, New York: Doubleday, 1967).

8. Quoted in Marcia Crosby, "Haidas, Human Beings, and Other Myths," in Karen Duffek and Charlotte Townsend-Gault, eds., *Bill Reid and Beyond*, 16.

9. Ibid., 10.

10. Claude Lévi-Strauss, *The Way of the Masks*, trans. Sylvia Modelski (Vancouver: Douglas & McIntyre, 1982; Seattle: University of Washington Press, 1988).

11. Peter Macnair et al, eds., *Down from the Shimmering Sky: Masks of the Northwest Coast* (Vancouver: Douglas & McIntyre; Seattle: University of Washington Press, 1998).

12. See Judith Ostrowitz, *Privileging the Past: Reconstructing History in Northwest Coast Art* (Washington: University of Washington Press, 1999); also Charlotte Townsend-Gault, "Art, Argument and Anger on the Northwest Coast" and Barbara Saunders, "Contested Ethnie in two Kwakwa̲ka̲'wakw Museums" in Jeremy MacClancy, ed., *Contesting Art: Art, Politics and Identity in the Modern World* (Oxford: Berg, 1977).

13. Personal communication with Debra Sparrow (Thelaquilwit).

Contributors

BRUCE BERNSTEIN was assistant director for cultural resources at the Smithsonian's National Museum of the American Indian for eight years, overseeing the museum's collections and research programs, including the building of the contemporary arts program. He is now with the Smithsonian's National Museum of Natural History, where he serves as a curator in the anthropology division. Bernstein has published broadly on Native arts and cultures and has curated numerous exhibitions. He served as a primary adviser for the exhibition *Native Modernism: The Art of George Morrison and Allan Houser* and for the symposium from which this book emerged.

J. J. BRODY is professor emeritus of art and art history at the University of New Mexico, Albuquerque, and former director of the university's Maxwell Museum of Anthropology. He currently holds research appointments at the Maxwell Museum, the Museum of Indian Art and Culture in Santa Fe, and the Indian Art Research Center of the School of American Research, also in Santa Fe. Brody's seminal doctoral dissertation was published as *Indian Painters and White Patrons* in 1971, and soon afterward he helped establish the doctoral program in Native American art history at the University of New Mexico. The recipient of numerous awards, Brody has curated many exhibitions and written a number of books.

TRUMAN T. LOWE (Ho-Chunk) is an internationally acclaimed artist whose abstract sculptures made of stripped willow branches and milled wood evoke the movement of rivers and streams, and the structures of the Wisconsin woodlands. Currently curator of contemporary art at the Smithsonian's National Museum of the American Indian, he is also a professor at the University of Wisconsin–Madison. Lowe curated the NMAI inaugural exhibition *Native Modernism: The Art of George Morrison and Allan Houser*, and edited the book of the same name published in conjunction with the exhibition. His own work is the subject of a recent book called *Woodland Reflections: The Art of Truman Lowe.*

GERALD McMASTER (Plains Cree and member of the Siksika Nation), curator, scholar, and artist, is the curator of Canadian art at the Art Gallery of Ontario. Recipient of Canada's 2005 National Aboriginal Achievement Award, McMaster worked from 2000 to 2005 with the Smithsonian's National Museum of the American Indian, where he was deputy assistant director for Cultural Resources and later responsible for design and content of three permanent exhibitions. McMaster co-edited *Native Universe: Voices of Indian America* (2004), published by NMAI in association with National Geographic for the opening of the museum in Washington, D.C., and to complement the themes of the museum's inaugural exhibitions. He was previously curator of contemporary art at the Canadian Museum of Civilization and curator in charge of the First People's Hall.

W. JACKSON RUSHING III is Professor of Aesthetic Studies and Associate Dean for Graduate Studies in the School of Arts and Humanities at the University of Texas at Dallas. He was formerly Chair of Art and Professor of Art History at the University of Houston. Recipient of a Guggenheim Fellowship and other awards, Rushing is also the author of numerous books and articles.

JOYCE M. SZABO is a professor in the Department of Art and Art History at the University of New Mexico, Albuquerque. She previously taught at Old Dominion University in Norfolk, Virginia, and served as Curator of American Art at the Chrysler Museum in Norfolk. Szabo has published widely on Native American art as well as the broader field of American art.

She continues to guest curate various exhibitions, including a retrospective of the work of the late Diné artist Conrad House at the University of New Mexico (2006).

CHARLOTTE TOWNSEND-GAULT is a professor in the Department of Art History, Visual Art and Theory at the University of British Columbia. Townsend-Gault has a background in art historical and critical writing, editing and curating in the field of contemporary art, and a long-standing involvement with aboriginal art, particularly in North America. Her current research focuses on the social relations that inform, and are formed by, the reception of First Nations cultural representations in British Columbia.

INDEX

Page numbers in *italics* indicate pages with illustrations.